Art Journal
COURAGE

Fearless Mixed Media
Techniques for
Journaling Bravely

Dina Wakley

NORTH LIGHT BOOKS
CINCINNATI, OHIO
CREATEMIXEDMEDIA.COM

Contents

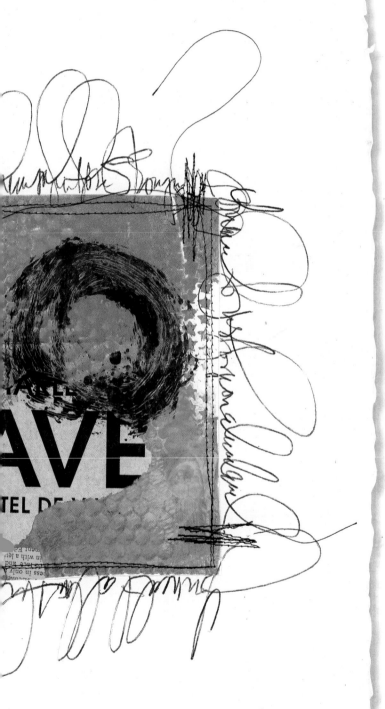

Be Strong
10³/₄" × 15" (27cm × 38cm)

Visit **CREATEMIXEDMEDIA.COM/ART-JOURNAL-COURAGE** for bonus downloads and more!

WHAT YOU NEED

12" × 12" (30cm × 30cm) wood panel

6 sheets of 9" × 12" (23cm × 30cm) watercolor paper

Adobe® Photoshop®, Photoshop Elements® or another software editing program

a photograph of your face

acrylic paint

acrylic spray sealer

alphabet stamp set (mine is by Stampotique)

Archival ink pad in black

baby wipes

ballpoint pen

black and hot pink spray paint

black paint marker

black pen

black pencil

book paper and other papers for collage

carbon paper

cardboard circle

cardstock or tag, white

color copy of a photograph (not an ink-jet print)

craft knife

cutting mat

Dylusions Ink Sprays

Fineline applicator bottle with black and teal fluid paints

fun foam

gesso

image for collage

image to trace

large envelopes

large tags

Lyra Color Giant pencil

matte gel medium

Neocolor II crayons

neon paint marker

old gift card

paintbrushes

PanPastels

paper towels

pencil

picture of you, from the knees up (or full length)

piece of canvas 12" × 9½" (30cm × 24cm)

piece of sticky-back canvas

print out of a clip art image you like (I used a butterfly)

Ranger Watermark pad

red paint marker

rubber stamps

scissors

sewing machine (or a hole punch, needle and waxed linen thread)

sheet protector

Stabilo All pencils in black and white

stencils (leaf, star, chevron mosaic)

vintage image

vintage photo

water spray bottle

white pen

your journal

your printer

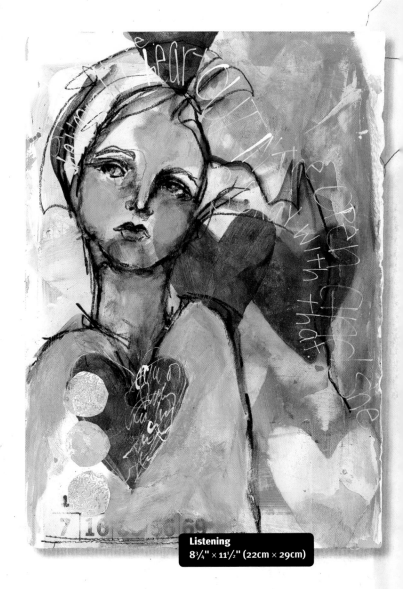

Listening
8¾" × 11½" (22cm × 29cm)

Visit CREATEMIXEDMEDIA.COM to sign up for the free newsletter!

3

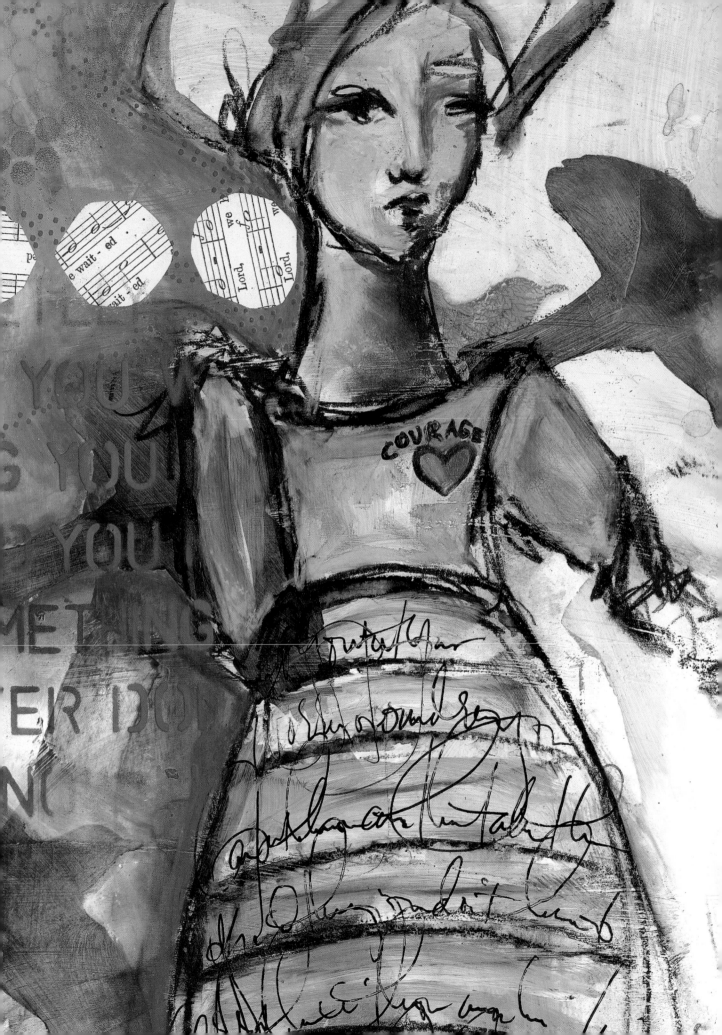

What Is Art Journal Courage?

"The worst enemy to creativity is self-doubt."
—Sylvia Plath

"I can't draw."
"I can't layer."
"I can't use my own photo; I'm not photogenic."

Need I go on? I hear these objections, and more, all the time. Some people hold themselves back. They tell themselves they can't create the art they long to create. They think they can't draw. Or that they don't know how to layer. They don't like to use their own image. They're afraid to step out of the art journal and make other projects.

Let's stop the self-doubt and negative self-talk and open yourself up to possibility and progress. I want you to be open and willing to make art you don't like. I want you to practice every day, to be devoted to your art making. Together we'll face common artistic fears, validate those fears and then overcome them.

By facing and acknowledging your fears, you can garner the courage to press on despite them. Practice and devotion will help you conquer those fears and create with courage. When you create with courage, you will create more art and better art than you ever have before.

Are you ready?

Courage
8¼" × 11⅜" (21cm × 30cm)

Visit CreateMixedMedia.com to sign up for the free newsletter!

5

Tools and Materials

Journaling supplies are very personal. Each journal artist has her own preferences for paint, paper and pens. I have found it valuable to try many brands and types of tools. When I find something I love, I stick with it. I'm happy to share with you what works for me. Your personal tools and materials list may consist of fewer items or many more.

Writing Tools

Pens

My main requirement for a pen is that it write over dried ink and paint. The key here is "dried." I can't tell you how many pens I've ruined trying to write over wet paint (patience is not my strong suit). These are my go-to pens:

Fude Ball 1.5: This is my current go-to journaling pen. It's a Japanese pen that has a big 1.5 mm roller ball. I've had good luck writing with this, even over bumpy surfaces and slightly wet surfaces. Even better is that I have not managed to kill a Fude Ball, despite the abuse I put them through. The ink is super dark and permanent when dry.

Paint pens: Paint pens are a logical choice for art journaling because paint writes on paint. I have had good luck with Montana, Sharpie and Posca brands. I only like water-based paint pens (no oil-based, thank you). I have nicknamed these "shaky pens" because you have to shake them for a good long time to mix the paint (especially the white). You also need to "burp" the pen regularly (i.e., press the nib into the pen to keep the ink flowing). The disadvantage to paint pens is that they tend to dry out quickly, sometimes they spit on your work and sometimes it's not so easy to get the paint flowing the way you want it

to. I put up with their quirks because they give me the look I like on my pages.

Sharpie Marker in Extra Fine Point: Extra Fine Point is different than Ultra Fine Point. The Extra Fine pens may be trickier to find. I have to buy them by the dozen at the office supply store. The nib is reinforced well and stands up to heavy use and rough surfaces.

Faber-Castell PITT Artist pens: The India ink in these pens is lusciously dark. I like the medium-size nib, but many different sizes are available.

Pencils and Crayons

I use pencils and crayons to sketch, journal and scribble.

Stabilo All pencil: This pencil is made for writing on slick surfaces like glass and plastic, which is what makes it so great for writing over dried paint. The lead is soft and gives a dark, impressive line. I call this the "magic" pencil because of its properties. It's water-soluble so you can run a wet brush over your lines to get a painterly look. If you mess up, you can get most of it off your page with a baby wipe. Because it is so easily removed, I often seal my work

6

Visit CreateMixedMedia.com/art-journal-courage for bonus downloads and more!

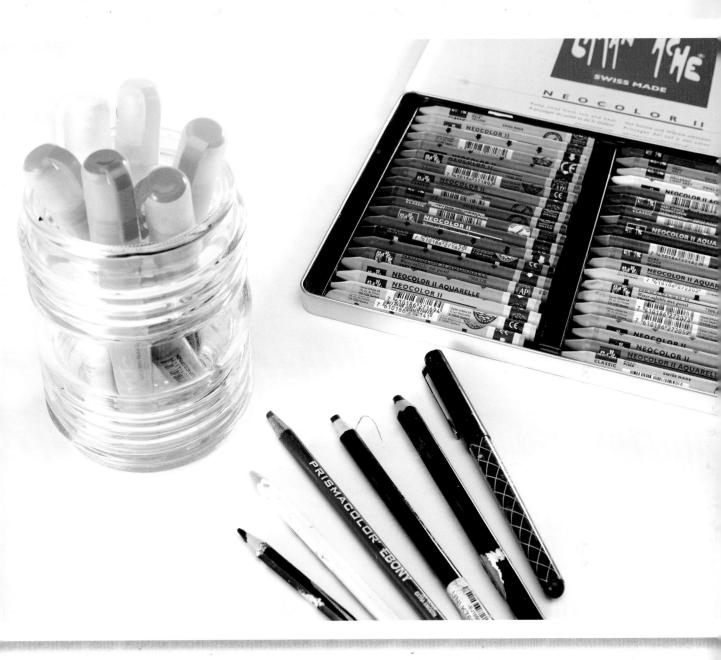

with fixative. I buy these by the dozen in both black and white.

Ebony pencils: A dark, soft pencil, the Ebony is not water-soluble, but is great for providing a dark line when a regular pencil is too light.

Charcoal: Charcoal comes in many incarnations (pencil, stick, twig, different hardness levels). I have many different types but tend to most often use a soft charcoal pencil because it's easy to grab out of my pencil box. It's delightfully smudgy. After I use charcoal in my journal, I seal it with Workable Fixatif.

Neocolor II crayons: Waxy, opaque crayons that are water-soluble. I find these indispensable to my process. They are fabulous for adding extra color both under and over acrylics.

Visit CreateMixedMedia.com to sign up for the free newsletter!

7

Paint and Brushes

Gesso: Gesso is like underwear for acrylic paint. You can get by without it, but if you do, something just won't feel right. Most of my pages start with a thin layer of gesso. The gesso coat gives acrylic paint something to hold on to. We call this "tooth." Gesso helps me use less acrylic paint because the paint doesn't soak into paper. Try putting paint on a piece of paper with gesso and a piece without gesso. You will see that the paint behaves differently on the gesso than it does on the plain paper. Many techniques I do are gesso dependent. They just don't work if the gesso isn't there.

Acrylic paint: I always say that paint is very personal. Some artists like fluid, some like heavy body. Some like transparent, some like opaque. When I developed my paint line with Ranger Ink, I had them make my favorite type of paint: one with a heavy body, a buttery brush feel and an opaque quality.

Fine Line Applicators: These needle-nosed bottles come empty; simply fill them with your preferred medium. I put acrylic paint in them and voilá! I have a custom tool that lets me draw, write and doodle on my pages.

Spray paint: I'm no expert at spray paint, so I often use brands from the hardware or craft store. I have treated myself to some artist-quality spray paints (such as Montana Gold), and oh my, they are fun. What's nice about artist-quality spray paint is you can buy different nozzles for your cans of paint to get different spray patterns.

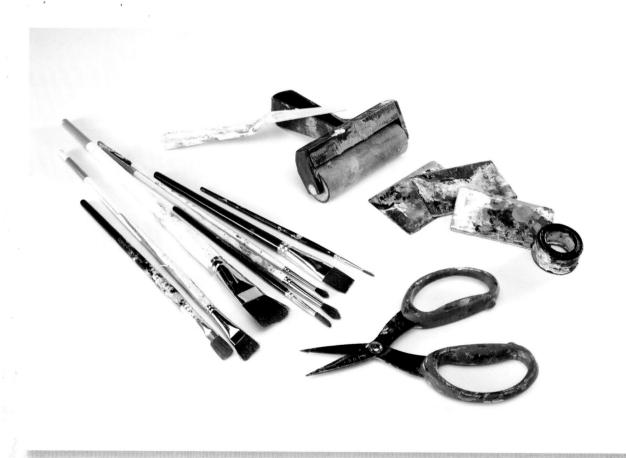

Visit CREATEMIXEDMEDIA.COM/ART-JOURNAL-COURAGE for bonus downloads and more!

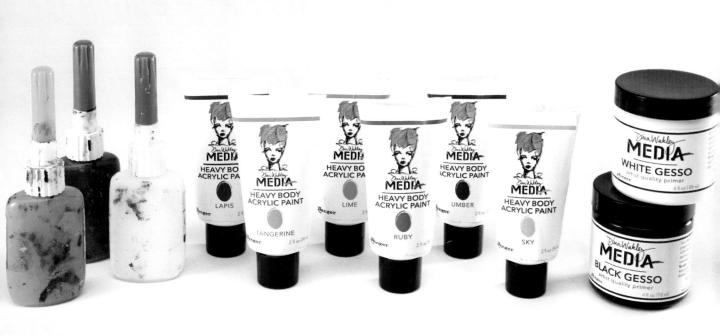

Brushes: I admit to being a chronic brush abuser. I do everything to them you're not supposed to do, like leave them in water pots for days at a time. When I designed my line of brushes for Ranger Ink, I told them I didn't want expensive brushes. I wanted an inexpensive brush with a stiff bristle and strong spring that would stand up to my abuse. Plus, I love the way heavy body paint looks when you apply it with a brush with strong bristles. You can see lovely, painterly brushstrokes and marks, and that's what I love.

Palette knives and scrapers: I use palette knives constantly. I often apply gesso with a knife because it's much easier to wash gesso off a knife than it is to get it out of a brush. I love to start backgrounds by scraping on paint with a knife or a scraper. Sometimes I paint a whole piece without ever picking up a brush.

Brayer: These are handy for applying paint smoothly and evenly to substrates, especially to printing plates and surfaces.

Visit CREATEMIXEDMEDIA.COM to sign up for the free newsletter!

9

Mixed-Media Play

Journals: I've used many types of journals over the years. Sometimes I make my own, but mostly I use the Dylusions journal by Ranger. I love the size, and I love that it lays flat. I gesso every page (of course) and it stands up to all of my layers and techniques.

Ephemera: Old sheets of music paper, book paper, printed paper, etc., are great for collage and backgrounds.

Gel medium: I like matte gel, though you can buy it in semi-gloss and gloss formulations. I use matte 99 percent of the time, which is why there is a soft matte gel in my line with Ranger Ink. I find matte gel to be the best adhesive for my journal (especially collage adhesive). I apply it with a palette knife or my finger. I'm a messy gluer, and matte gel is unobtrusive on my work. If there's glue where it shouldn't be (and knowing me, there will be), it's matte when it dries and therefore doesn't draw attention to itself.

Spray inks: I am a slave to spray ink. I love it. Spray inks give you a look that you can get no other way. However, spray inks are messy and unpredictable. I always say the

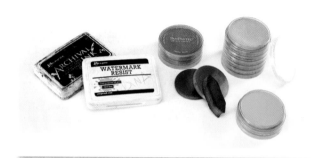

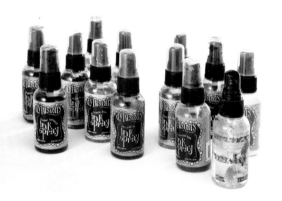

three words you will say most when you use spray ink are, "Oops! Oh, well!" Be at peace with the *oops* and you'll come to love spray inks as much as I do. My most-used inks are Dylusions by Ranger Ink. These inks are densely pigmented and are reactive with water, giving you many technique options. And the White Linen, oh the White Linen! It's opaque and dries wonderfully on acrylic paint.

Stencils: You'll find great art stencils on the market if you don't feel like making your own. I designed my new stencils with Ranger Ink on a 6" × 9" (15cm × 23cm) footprint, because I love to move the stencil around the page and stencil in small areas at a time.

Ink pads: I love a good black ink pad, and the Jet Black Archival pad by Ranger Ink is my most-used pad. It stamps well over acrylic paint (a must for me) and is permanent when dry so there is no smearing when you color your image. You can also buy Archival pads in many other fabulous colors. I use the Watermark pad when I want a tone-on-tone look or when I want to use my stamps with PanPastels.

Stamps: Stamps are a great way to get imagery into your journal, especially if you're not comfortable drawing. You need stamps. Lots of them.

Mark-making tools: Cardboard circles, combs, awls and even LEGO pieces are great to use as mark-making tools.

Modeling paste: Modeling paste and stencils are made for each other. Modeling paste gives a raised, dimensional look. It's paintable and sandable, and so fun to play with. I always apply paste with a palette knife.

PanPastels: PanPastels are unique. They are artist-quality pastels packed into a clear pan. Just about anything you can do with paint, you can do with PanPastels.

Visit CREATEMIXEDMEDIA.COM/ART-JOURNAL-COURAGE for bonus downloads and more!

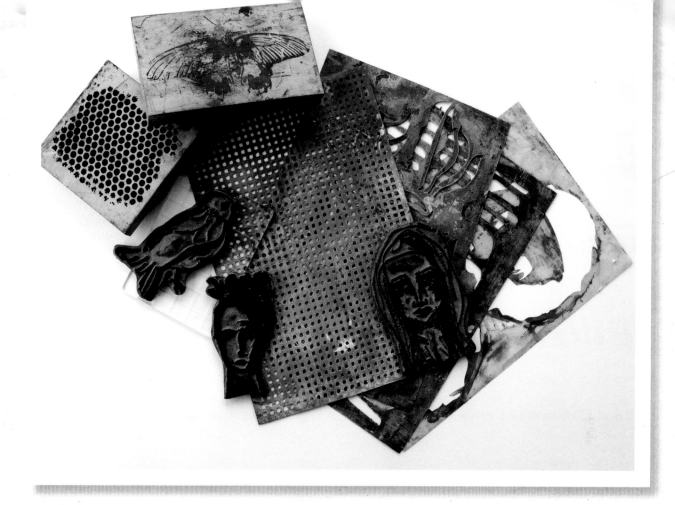

They produce very little dust, so you don't make a big mess when you use them. I love to use them to make backgrounds and to color images. I've even painted faces with them. The colors are extremely blendable. And if you don't like what you did, you can remove some of the pastel from your page with a white eraser.

Workable Fixatif: I rely on this to seal pencil and charcoal work, if I don't want it to smear. I use Workable Fixatif versus a spray polyurethane because I often want to continue working on my page after I've sealed it. The Workable Fixatif leaves some tooth on the page so you can continue to apply more layers. Other sprays are meant to be sealants and you use them at the end to seal your work.

Transfer paper: This is great if you love to draw but feel like you aren't very good at it. Find images you like and trace them onto your work with transfer paper. Super easy!

Tools

Cutters: I love a good pair of scissors and my favorites are the Tonic scissors by Tim Holtz. If I do something that requires measuring, I use a scrapbooking-type paper cutter.

Spray bottle: I keep a mister filled with water on my desk at all times. I use it to refresh ink on stencils, add water to my page and even add water to paint that I'm mixing.

Paper towels: I'm picky about my paper towels. I only use Viva because of their strength and their lack of an embossed pattern. Paper towels will help your spray ink endeavors succeed. I don't remove the paper towels from the roll. I simply spray, remove the stencil and make one pass over my page with the roll of paper towels. I use the paper towels until they're super dingy, then I just tear off the inky sheets.

Visit CreateMixedMedia.com to sign up for the free newsletter!

11

Courage to Express

Fear: I don't know what to write! And . . . I don't like my handwriting.

Courage: Writing takes practice! Plus, the only person who doesn't like your handwriting is you.

To me, an art journal is still a journal. I do believe that art has a visual language and can speak for itself, that you don't necessarily have to write words on everything. However, I find I do write on most of my journal pages. Sometimes I just write one word, but I do write.

I have kept a personal journal since I was nine years old. I have eighteen volumes on the shelf, so I've had lots of practice putting myself down on paper. Writing down my life, my thoughts, my soul, is an ingrained part of who I am. I have to do it, I am compelled to do it.

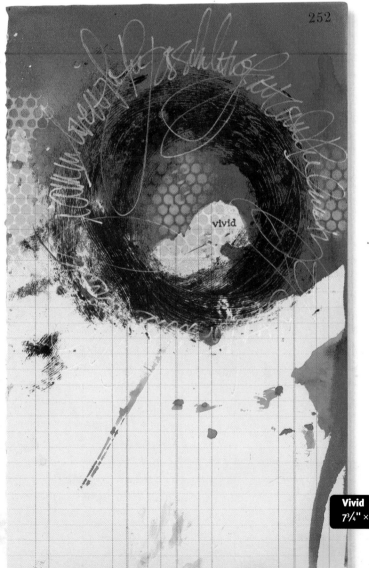

Vivid
7³/₄" × 12¹/₂" (20cm × 32cm)

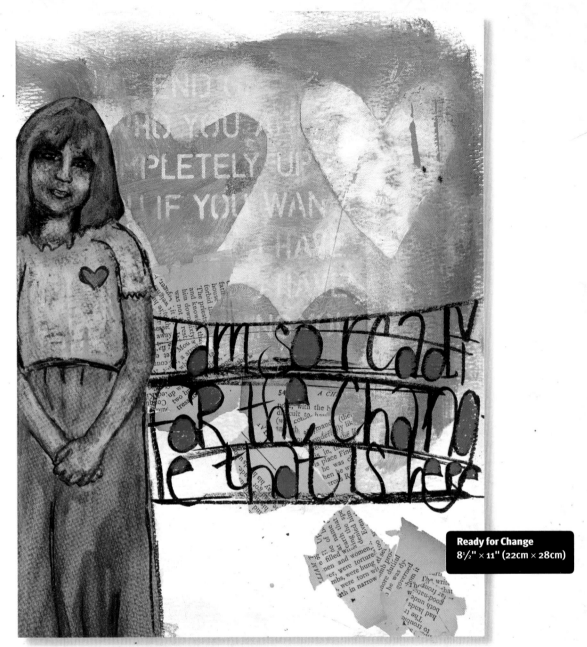

Ready for Change
8½" × 11" (22cm × 28cm)

People often ask what I write in my art journal. I write everything: fears, sorrows, insecurities, happinesses, my to-do list, rambling musings. I also write mundane things like how I hate laundry and how I'm always driving the kids somewhere. The text in my journal isn't always deep and introspective. Sometimes it's just about my day. Sometimes it's about nothing. I write whatever is authentic to that exact moment.

As I teach art journaling classes all over the world, I often hear, "I don't know what to write." Or, "I hate my handwriting." I recognize and understand that not everyone finds it easy to write. I get it. But I don't buy those excuses.

Let me tell you a little story about my grandmother. She had a stroke when my mother was twelve years old.

Despite a poor prognosis, she recovered and went on to do all of her work in the house and on the farm, as well as to serve in her church and community. She even drove a car despite being paralyzed on her right side. She kept a journal in which she wrote just one or two sentences a day. That's it. Do I wish she wrote more? Well, sure, but I can't tell you how grateful we are for those few sentences. One of my favorites is, "Lester [my grandfather] is mad at me today." That one makes me laugh. See how one little sentence is meaningful, and helps me know her, helps me love her?

Writing yourself down is important. Vital. Crucial. This chapter has exercises and tips to help you express yourself with words.

Visit **CreateMixedMedia.com** to sign up for the free newsletter!

13

Today in a List

I used to be a technical writer, and one of a technical writer's favorite things is a bulleted list. I love lists! Here's why:

- They're easy to write. And read.
- There's no pressure when you write a list like there is when you write a long paragraph.
- There's no need for perfect grammar—or perfect anything for that matter.
- Lists are instant satisfaction! You can write one quickly.

I have a document for you called "Today in a List." I want you to fill it out every day. Find five minutes to sit down and do it.

If you want to start digging deeper now, try also filling out the "Today in a List: The Dig Deeper Version." The prompts on that list are a little more introspective. If you look at that one and think, "I got nothing . . ." don't worry. I'm not your therapist. You don't have to dredge up your innermost feelings. I'm just trying to give you some tools you can use to jump-start your writing.

MATERIALS

pen

Today in a List

Today in a List: The Dig Deeper Version

your journal

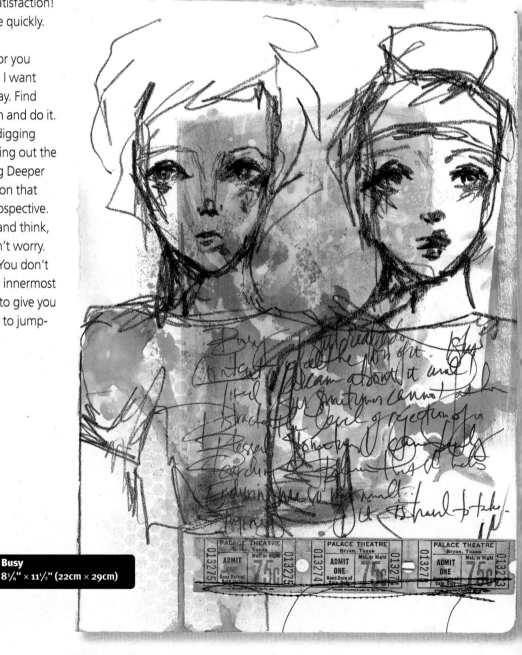

Busy
8³⁄₄" × 11¹⁄₂" (22cm × 29cm)

Today in a List

Date:

5 Things I Did Today . . .

5 Things I Felt Today . . .

5 Things I'm Grateful for Today . . .

5 Frustrations I Felt Today . . .

5 Things That Made Me Happy Today . . .

5 People I Interacted With Today . . .

5 Random Things About Today . . .

5 Things I Need to Do Tomorrow . . .

Today in a List: The Dig Deeper Version

Date:

5 Details I Noticed Today . . .

5 Things I Hungered for Today . . .

5 Masks I Wore Today . . .

5 Questions I Have Today . . .

5 Ways I Was Enough Today . . .

5 Good Parts of Me Today . . .

5 Quiet Moments From Today . . .

5 Bad Parts of Me Today . . .

Mind Map

Now let's use a mind map to nudge your journaling just a bit further. You've probably used a mind map in grade school. It's a classic writing and brainstorming technique. What's great about it is that it forces you to delve deep into something, and it helps you remember details you wouldn't have remembered otherwise. Better still, it's a lot easier than writing a long paragraph.

To create a mind map, draw a box on your page. Select one thing from your Today in a List paper. Write it in the center box. Then draw a line out from the box and write the first thing that comes to your mind. Draw another line and write the next thing. Continue on the same thought as long as you wish. Start new branches and offshoots as you think of other things that relate to what's in the box.

For example, I took "made bread" off my Today in a List sheet. I wrote "I made bread today" in the box, and then I started writing. Within a few short minutes, I had recorded lots of details about that simple list item, like why I decided to make bread today, where I bought my new Cuisinart, things my boys said when I was grinding my wheat flour, etc. As I did this, I even remembered that my mother makes awesome bread and that her mother did, too. Wow . . . I got all that from "made bread." Isn't that the coolest? Look at all those details!

Little details are fun to put on art journal pages . . . that's why we're getting in the habit of documenting our lives and using tools to record and remember the details. Save all your lists and mind maps; you can refer to them as you create your pages. When you don't know what to write on a journal page, pull out your lists and maps. You can choose an item from the list and expound on it on your page!

MATERIALS
pen
your journal

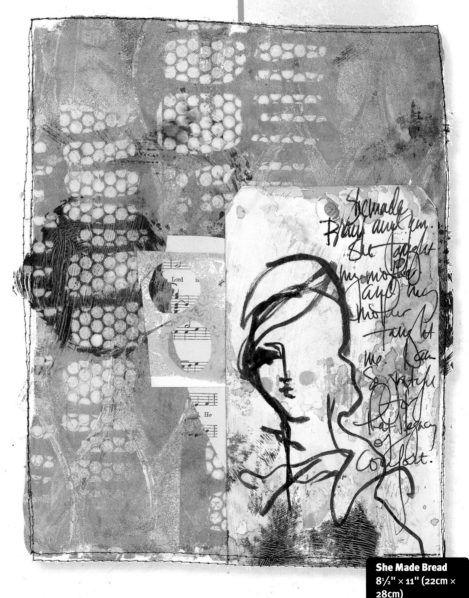

She Made Bread
8½" × 11" (22cm × 28cm)

tastes milder than real wheat

white wheat

they thought I could grind my fingers, you can't

w/ real butter eat it hot

love to

kids thought it was so noisy

love the smell of bread!

grandma maxfield made fab bread, too

used my wheat grinder

Pick a something from your list
and write it here.

I made
bread today

my mom is a great cook — taught me art.

bread

100% wheat flour

got new Cuisinart

mom gave me my first one

old one broke ... DOH

new one = black & chrome

cost $199

had to replace it — use it a lot

chefscatalog.com

tested it out

used Jenni Bowlin guest DT moolah

100% whole wheat bread

bread, rolls, dough

once-a-month cooking prep.

yum!

Write something from your Today in a List in this box, and start mapping.

Visit CREATEMIXEDMEDIA.COM to sign up for the free newsletter!

19

Stream of Consciousness

Let's try "stream of consciousness" writing. Stream of consciousness is a narrative technique. In creative writing, it shows a character's thought processes. For journaling, I use it to get words and feelings out on the page without worrying about proper grammar, proper style, proper anything.

How to Write in a Stream of Consciousness Format

1. Pick something off your Today in a List papers.

2. Write it on the line at the top of the page.

3. Start writing. Write the first thing that comes into your head.

4. Keep going. Don't pick your pen up from the page, don't use periods, don't stop writing for any reason. As your thoughts change, just write them down. Don't edit yourself!

5. Notice what details and inner thoughts emerge when you don't use periods and pauses to stop the flow of ideas and emotions.

MATERIALS
pen
your journal

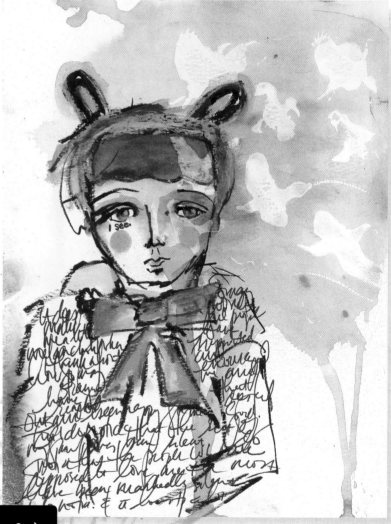

I See
8½" × 11" (22cm × 28cm)

Visit CREATEMIXEDMEDIA.COM/ART-JOURNAL-COURAGE for bonus downloads and more!

Example of Stream of Consciousness Journaling

Here's a stream of consciousness paragraph I wrote a few years ago:

Stream of (barely) consciousness....So yesterday Cole looks at me with those big, big brown eyes and says remember you said I can have a dog when I'm a teenager, and I said yes but inside I said oh crapezoid how do I get out of this and I wonder if I'll be able to distract him with a car or a laptop or something teenagers dig mucho but he is one stubborn niño and he remembers that 2 years ago I said he could have a dog when he turned 16 and the guilt rages but the fact of the matter is I'm a lousy housekeeper and I can barely keep my kids washed and fed and a dog, ugh, a dog would just be so tempting to ignore and I just can't take the poop and frankly a dog deserves a good owner, not me and today I woke up tired from another night of vivid dreaming and I've had way too much soda and the diuretic effect has kept me home all day and I am just so blobby and sad for no good reason so that is today, it is what it is. (Journal entry written January 2007.)

Do you see how, in the paragraph above, I start writing about my son's desire for a dog and by the end of the paragraph, the real truth is revealed . . . I felt "blobby and sad for no good reason." That's why I love stream of consciousness—the uninterrupted flow of ideas works its way down into the real crux of things. It's a great way to dig deep.

Is stream of consciousness rambling and run-on? Well, sure. That's what makes it a true reflection of your thoughts.

You can write in a stream of consciousness style on your journal pages. Just put your pen to paper and GO.

Choose something from Today in a List and write it here:

Okay . . . Put your pen on the paper and write (remember, no periods, no lifting the pen from the paper). Ready, go!

Visit CREATEMIXEDMEDIA.COM to sign up for the free newsletter!

21

Prompts

If you are having a hard time putting yourself down on paper, try using writing prompts to get started. Many different prompt books that give you writing ideas and topics are available. Also try Googling "journal jar" or "journal prompts."

Many journal artists enjoy using prompts as nudges to get them journaling more. Try a few prompts. You might even dedicate an entire journal to them.

MATERIALS
pen

your journal

What Is Art to Me
9" × 12" (23cm × 30cm)

What is art to you?
What is your favorite childhood memory?
What is on your bucket list?
What is your biggest regret?
If you had an extra hour every day, what would you do with it?
What is your favorite quote, and why?
What is your favorite book, movie, song?
Would you like to be famous? Why or why not? What would you like to be famous for?
Which quality do you dislike most about yourself?
Which quality do you like most about yourself?
When do you feel proud?
Where is your happy place?
What is your strongest life influence?
What does friendship mean to you?
Describe a time when you felt vengeful.
I wish I could . . .
What makes you laugh?
What makes you feel safe?
What is happiness?
Who is your strongest life influence?

Your Handwriting

I hear it all the time, "I hate my handwriting." Or students tell me, "You can write on your pages because you have good handwriting."

All right, time to face the truth. No one, and I mean no one, will look at an art journal page you have made and think, "Oh, she ruined it by writing on it." And, no one, I mean no one, hates your handwriting but you.

"Good" handwriting is a matter of practice. If you want your handwriting to improve, you need to write. Try the exercises in this chapter and work on it regularly. Your handwriting will improve if you work on it.

I do admit that much of the handwriting in my journal is illegible. I purposely exaggerate my writing so it becomes decorative and gives me a bit of privacy (since most of my pages go on my blog or are published in some way, my crazy handwriting protects me). I always say I don't write checks to the gas company with the same handwriting that is in my journals. Consider developing a "journal" handwriting that you use in your artwork.

MATERIALS

pen

your journal

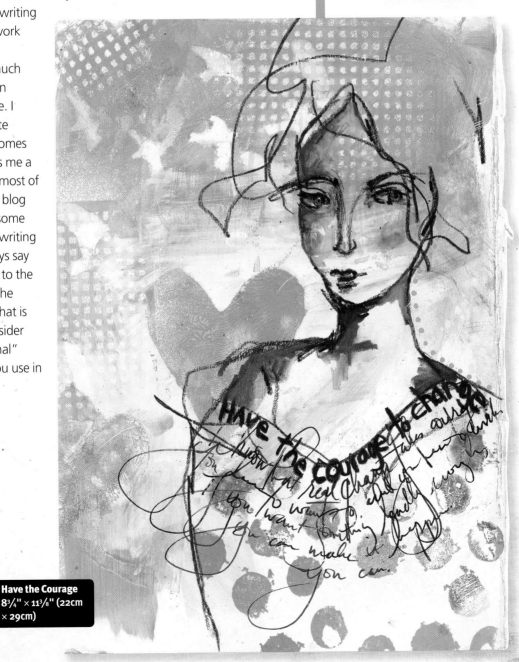

Have the Courage
8³⁄₄" × 11³⁄₈" (22cm × 29cm)

Visit CREATEMIXEDMEDIA.COM to sign up for the free newsletter!

23

Keys to Dina-Style Handwriting

- Choose a good pen. I like a pen that has thick line and smooth flow. Pens are personal, though, so try a bunch to find your favorite. You shouldn't have to fight with your pen. It should make writing easy.
- Grip the pen and elevate your elbow slightly. Write with your whole arm, not just your fingers. If you use only your fingers to move the pen, your hand will get tired quickly. Your fingers and wrist shouldn't move at all—your forearm should be guiding the pen from your shoulder.
- Sit up and have good posture.
- Letters are made up of basic marks, so start by making marks on a piece of notebook paper. Make lines, slashes, Xs, Os and squiggles. Make them big, because it's easier to start big and then work smaller as your proficiency improves. If your marks are uneven, practice until you can make them evenly.
- Commit to practicing ten minutes a day. As your marks improve, start writing the alphabet or copying paragraphs from a book. Concentrate on making each letter shape the same each time.
- As you get more comfortable, try exaggerating the letters to develop a signature style. I like to make big loops.
- Just write! You can't get better by complaining about it. You have to put the work in.

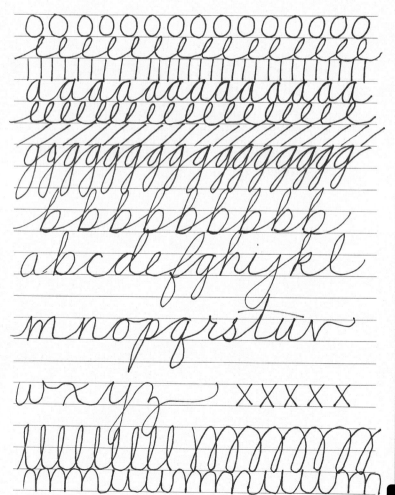

Exercises

Visit CREATEMIXEDMEDIA.COM/ART-JOURNAL-COURAGE for bonus downloads and more!

Visit CREATEMIXEDMEDIA.COM to sign up for the free newsletter!

25

Courage to Draw

Fear: I can't draw.
Courage: You can draw once you know the formula.
And once you commit to practice!

"I can't draw." I can hear you saying it now. I know you think you can't do it, because that's what I used to say. In fact, in the first online art journaling class I ever taught, I told everyone that I used stamps and stencils because I couldn't draw.

Years went by, and I enjoyed stamps and stencils, and I made lots of cool art. I would see journals with drawing in them, and I would think, "Too bad I can't draw."

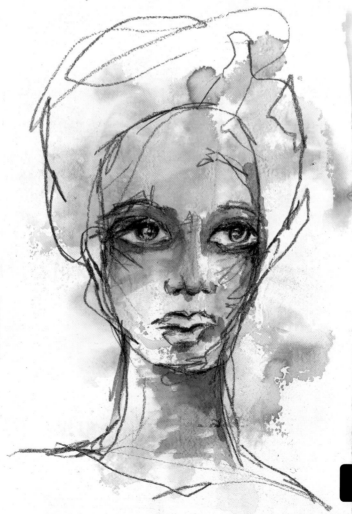

Study in Plums
10½" × 15" (27cm × 38cm)

Visit CREATEMIXEDMEDIA.COM/ART-JOURNAL-COURAGE for bonus downloads and more!

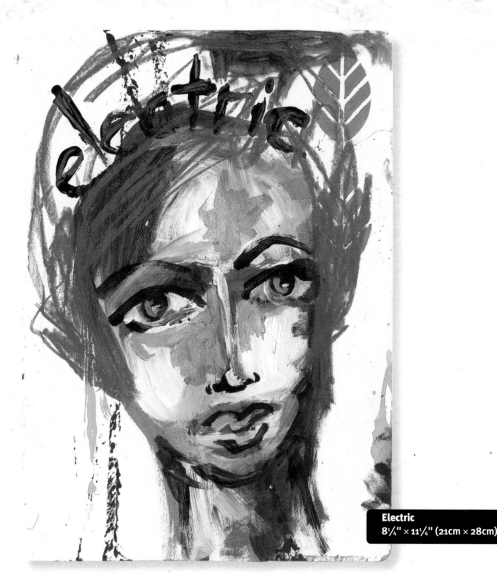

One year, sick of the lack of artistic progress I was making, I changed my thought process. Instead of saying, "I can't draw," I said, "Why can't I?"

Guess what I found out? I can draw. And so can you.

A few years ago there was a reality television show called *Work of Art*. The show was canceled after two seasons, unfortunately, but I loved watching it because it showed me how "real" artists make art. I learned two very important lessons from this show.

First, I learned that artists use references. I had always assumed that artists pull ideas for their artwork out of their brains. And yes, some do. But as I watched the reality show, I realized that almost all of the artists used references to help them create. By references, I mean photographs and other source materials from which they derived or inspired their artwork. This was a lightbulb moment for me. It is not cheating to use a reference. In fact, you make better art when you use a reference.

Second, I learned that artists trace. Yep, trace. Not all the time, not for every piece, but artists trace sometimes to get proper line and proportion. There's even a machine you can buy that will project an image up on the wall for you. You simply tape up your paper and trace the projected image. This was another lightbulb moment. It is not cheating to trace. In fact, tracing can help you train your hand so you draw better when you don't trace.

Later I learned a third lesson about drawing. Every drawing you do makes you better. I was thrilled with the first face I ever drew, because I had never done it before. But now, a few years later, my drawing has improved immensely and that first face doesn't look so great. I still love it, though, because it's my "I can do this!" face. To get better at drawing, you have to draw. You have to be devoted to it. You don't learn to draw in a day. You learn as you devote time to practicing. I feel like I am still constantly learning ways to improve, ways to draw better. Drawing is a journey, and you have to be willing to put the work in to get good results. You also need to be gentle with yourself, to recognize small improvements and to banish the self-critic.

Visit CREATEMIXEDMEDIA.COM to sign up for the free newsletter!

27

Tracing to Train Your Hand

Let's start our drawing journey by tracing.

A few years ago I was chatting with my good friend Dyan Reaveley about drawing. Dyan is a fabulous mixed-media and journal artist who has her own Dylusions product line that includes my favorite ink sprays as well as hand-drawn stamps and stencils. She started her drawing journey by tracing. She said there was a little leaf shape that she adored and so she traced it on everything—journal pages, wood pieces she was going to paint, you name it. After tracing that leaf over and over, she found that her hand could draw it without tracing. Essentially she trained her hand how to draw that shape. Genius!

When I realized that I could trace images in my journals, I was ecstatic. With tracing, any image is fair game. Flowers, shells, bugs, faces, landscapes, doorways, leaves, birds . . . yes! After you trace an image, you can alter it, decorate it, paint it. The tracing is simply a springboard, the rest is up to you.

MATERIALS

an image to trace

black pen

blue Neocolor II crayon

gesso

ink sprays (Bubblegum Pink, Squeezed Orange, White Linen)

paintbrush

paper towels

piece of carbon paper

regular pencil

Stabilo All pencil

stencil

Titanium White paint

water mister

your journal

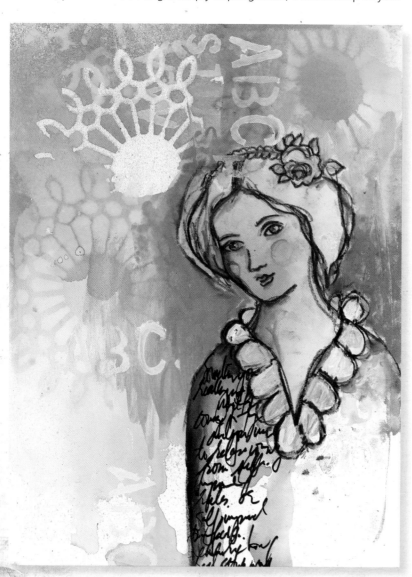

Visit CreateMixedMedia.com/art-journal-courage for bonus downloads and more!

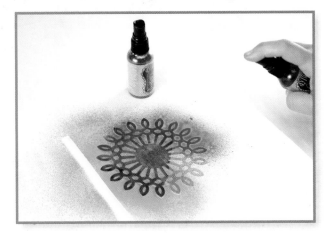

1 Gesso a page in your journal and let it dry. Lay a stencil down and spray over it liberally with Bubblegum Pink and Squeezed Orange ink.

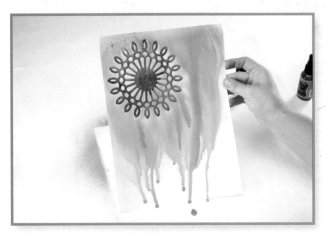

2 Without removing the stencil, spray water over the bottom of the stencil and allow the ink and water to run down the page and stencil.

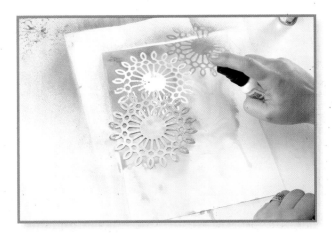

3 Remove the stencil and blot a little bit with a roll of paper towels, if necessary. Don't blot too much because you'll remove too much of the ink from the gesso. The key to using ink on gesso is to avoid blotting.

Lay the stencil down in another place on the page and spray over it with White Linen ink a few times. Allow the inky background to dry. Place the stencil in another spot on the page and repeat. Remove the stencil and flip it over to use the remaining ink on the page.

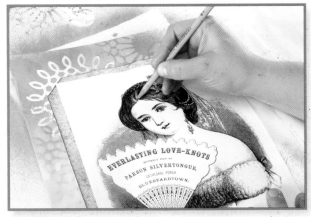

4 Lay carbon paper on your page (black side down), and then place the printout of an image over it. Trace your image with a pen or hard pencil.

Tracing Tips

Press hard! I trace the most important lines, not every detail line. Grab a marker and trace all the shapes in a magazine. It's great practice for your hand.

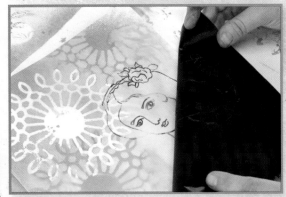

Visit **CreateMixedMedia.com** to sign up for the free newsletter!

29

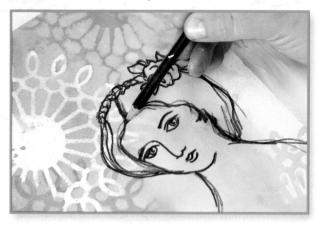

5 Remove the image and the carbon paper, and go over the lines with a sharp Stabilo All pencil.

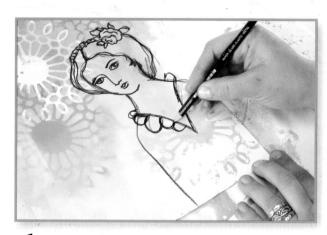

6 Add any other detail to the image you like. I added a body, neckline and collar. Scribble over the lines a bit, varying the pressure with the pencil.

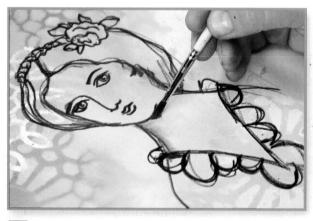

7 Go over some of the lines with a wet paintbrush. Don't dissolve every line that you wet. Just dampen it to give it a bit of shading.

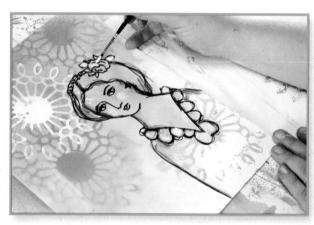

8 Add Titanium White paint highlights in a few areas. I put white paint in the whites of the eye, the catchlight, the cheeks, the rose in her hair and the scallops of the collar.

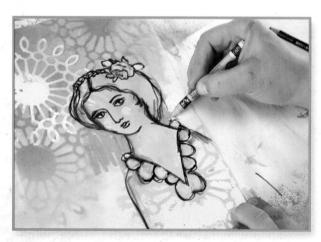

9 Color around the image a bit with a blue Neocolor II crayon.

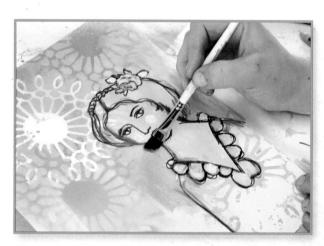

10 Take a wet paintbrush and dissolve a bit of the blue area to blend it.

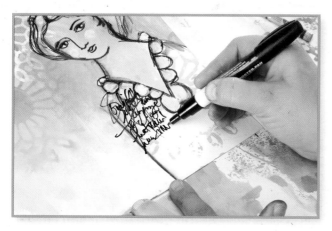

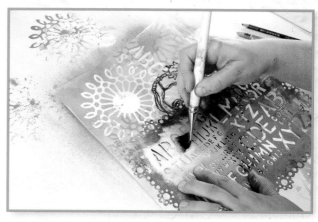

11 Use a black pen to add journaling to your page.

12 Use a dry brush, Titanium White paint and a stencil to add top texture to the page.

Extra Inspiration

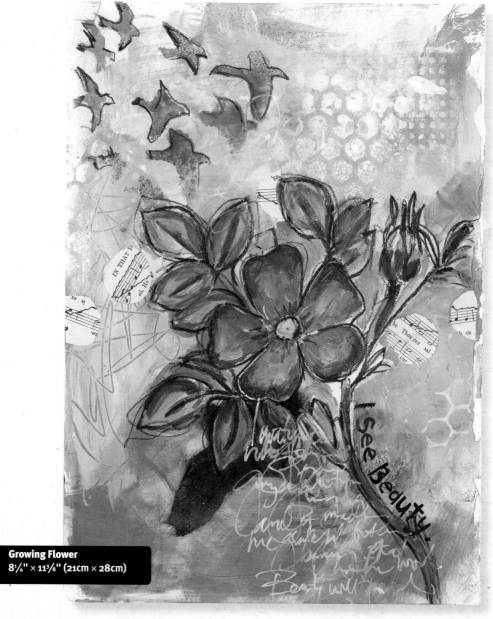

Growing Flower
8¼" × 11⅜" (21cm × 28cm)

Visit CreateMixedMedia.com to sign up for the free newsletter!

31

Drawing Simple Shapes

It's time to freehand draw some simple shapes. Start with a circle or two. Then draw a few petals on the circles. Voilá, you have a flower. Draw a curvy line and add leaves. Look, a climbing vine. Draw hearts. Draw stars. Get your hand in the habit of moving and making marks on your page. You're not making a masterpiece here, you're practicing your drawing on a journal page.

Simple shapes are the foundation of drawing. Everything can be broken down to basic shapes like circles, rectangles and triangles. A daisy is a circular center with oval or triangular petals. A human face is an oval, with oval eyes, a triangle nose and a rectangular neck. So it's worthwhile to practice drawing simple shapes and to get used to making your own mark on paper.

One thing to remember when you're drawing is that your goal is not necessarily accuracy. It's line, energy and suggestion. So don't get caught up on accuracy. The vines I draw don't look like a real vine. But they're flowing and free, and I like them. That's what matters.

MATERIALS

acrylic paint (Green Gold, Light Blue Permanent, Titanium White, Magenta, black)

baby wipes

black pen

cardboard circle

gesso

old gift card

paintbrush

Stabilo All pencil

stencils

White Linen ink spray (Dylusions by Ranger)

your journal

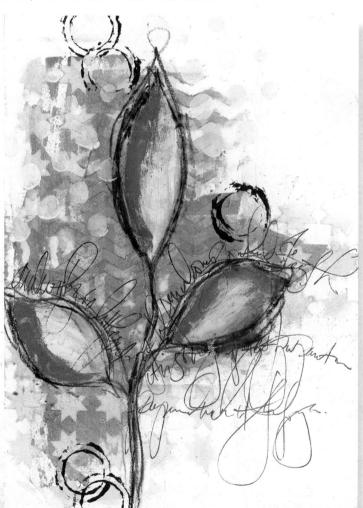

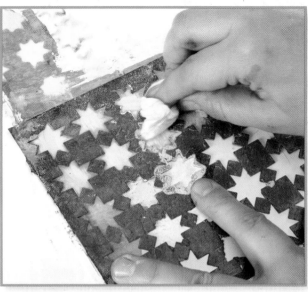

1 Gesso a page in your journal and let it dry. Use an old gift card to scrape some Green Gold acrylic paint onto part of the page.

2 Place a stencil over the paint and rub through it with a baby wipe.

Blot Your Wet Wipe

If the wipe is too wet, moisture will seep under the stencil and muddy your design. I often dry out my wipe a bit by blotting it onto my apron.

3 Use the gift card to scrape some Light Blue Permanent acrylic paint onto the page.

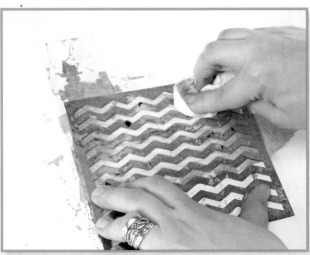

4 Place a stencil over the blue paint and rub through it with a baby wipe.

Visit CREATEMIXEDMEDIA.COM to sign up for the free newsletter!

33

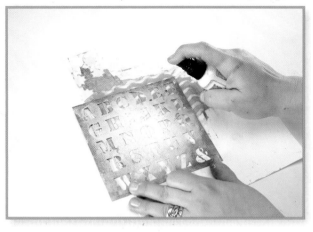

5 Use White Linen ink spray and a stencil to add some white stenciling to a few areas of the background.

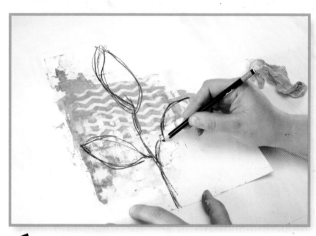

6 Draw a simple shape onto your background with the Stabilo All pencil.

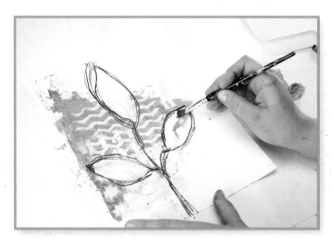

7 Paint inside the shape with Titanium White paint.

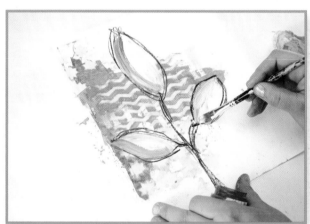

8 Before the white paint dries, add some Magenta paint to the area inside the shape. The pink is complementary to the green so it provides contrast and pop.

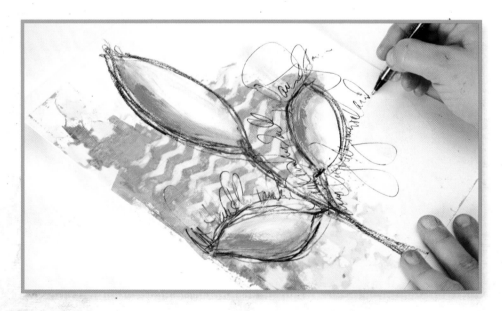

9 Allow the paint to dry, then write around your shape with a black pen. Spill your soul!

Visit CreateMixedMedia.com/art-journal-courage for bonus downloads and more!

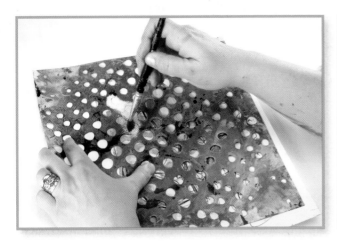

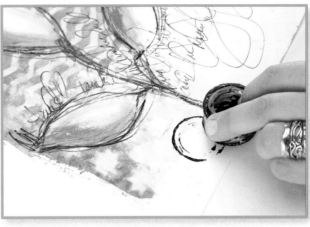

10 Use a dry brush, a stencil and Titanium White paint to add some top stenciling to your page.

11 Dip a cardboard circle in black paint and add paint circles to your page. I always do an odd number—three, five, seven.

Extra Inspiration

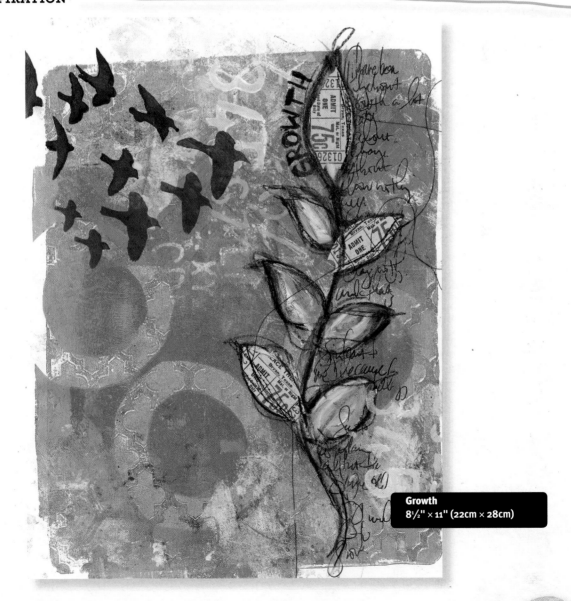

Growth
8½" × 11" (22cm × 28cm)

Visit CreateMixedMedia.com to sign up for the free newsletter!

35

Drawing Faces

Artists discovered formulas for drawing the human form during the Renaissance in the sixteenth century. I think it's important to learn the formula, because then you can tweak it (or even completely abandon it) for your own creative purposes. The official formula is quite mathematical and complicated. It involves lots of lines and measurements, not just for eye, nose and mouth placement but even for the size of the iris inside the eye.

Well, I don't do numbers well, so this is my adaptation of the formula. I have simplified it enough to make it workable for me, to give me guidelines without being too technical and overwhelming. You'll be amazed how your drawing improves when you follow a few basic rules.

The formula in this chapter is for a front view, also called a 100 percent view. When the head is turned even slightly to the side, the formula changes a bit.

Keep in mind that all aspects of a face (shape, eyes, mouth) vary according to race and genetics. I'm not trying to draw photo-accurate people. I love line and expression, so I want to draw people who are emotive and interesting. That's what matters to me.

I cannot stress enough the importance of using reference photos when you draw. I recommend starting a Pinterest board or collecting images of faces that you like, both real and drawn. When you get stuck on drawing an eye or a nose, look at your reference photo. When your drawing seems off, compare it to the reference photo and identify the differences. Remember that using a reference photo isn't copying, it's what real artists do when they make art. If my drawing ends up looking a lot like my reference photo, I give credit to the original artist. Most of the time, though, my drawing has my own style and flair, and the reference photo was simply there for inspiration.

Grab your courage and let's draw!

MATERIALS
paintbrush and water
Stabilo All pencil
your journal

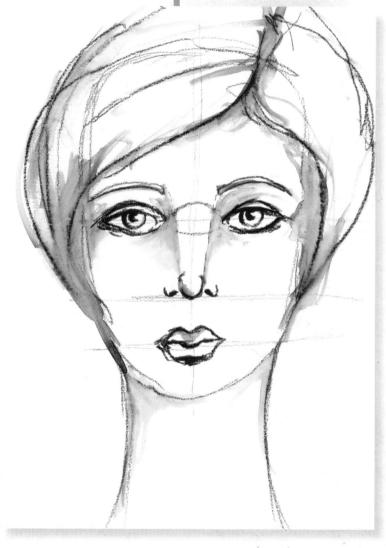

Visit CreateMixedMedia.com/art-journal-courage for bonus downloads and more!

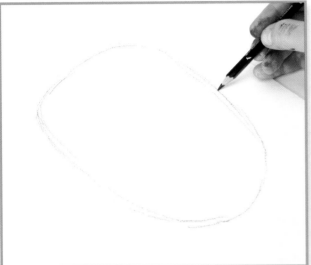

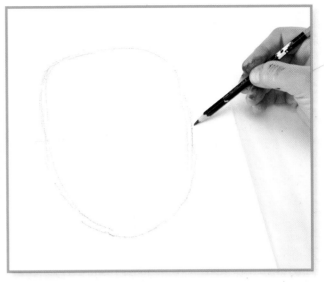

1 Draw a head shape. The mistake most people make is making the head too round. The head is more oval or egg-shaped than round, with flattish sides.

2 Sketch in two lines that divide your head shape in half vertically and horizontally.

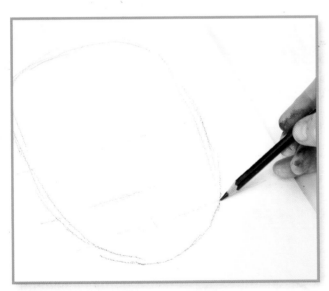

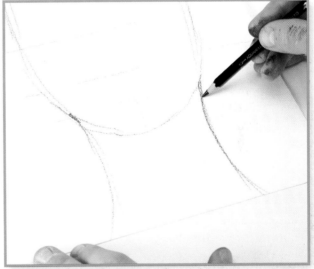

3 Divide the lower half in half (so you're making a line at the one-quarter mark). Then divide the area under your one-quarter mark in half (so you're making a line at the one-eighth mark).

4 Touch the sides of your mouth and then move your fingers back toward your ears. Do you see that your earlobes are lined up with your mouth? Now touch behind your earlobes. What can you feel back there? Your neck! Your neck begins behind your ears. A common mistake people make is making the neck too thin (I call that a "bobble head" neck). Start your neck at the mouth line.

Visit CREATEMIXEDMEDIA.COM to sign up for the free newsletter!

37

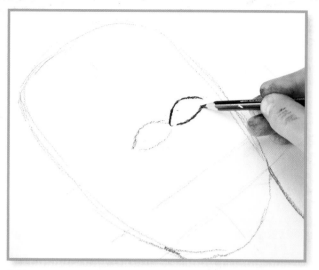

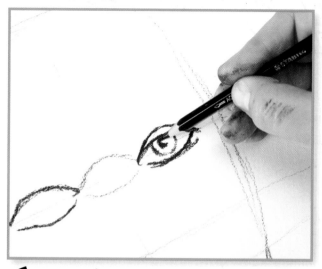

5 Eyes go on the eye line. It's a common mistake to make the eyes too high. I promise you, your eyes are in the center of your head (remember we're measuring from the top of the head and not the hairline). Eyes are one eye width apart, and one eye width from the side of the head. Ears go between the eye line and the mouth line.

6 Draw in the eyelids, iris and pupil. The pupil should have a catchlight.

A Note About Eyelashes...

I don't draw them in because they are tricky to draw in a way that makes them look natural, especially when using a thick pencil like the Stabilo. I use a darker stroke on the lash line to emulate lashes.

Eye Tip

Beginners commonly draw eyes like this (top right).

What the eye at the right is missing is eyelids. Take a look at your eyes, or the eyes of someone around you. You cannot see the full circle of her iris, right? The upper and lower eyelids cut off the iris on the top and bottom of the eye. And, you can see a catchlight—a reflection of light in or near the pupil. Catchlights are what make people look alive. When you are painting a face, you can put the catchlight in with white paint. But when you are drawing, you need to leave some space open for the catchlight.

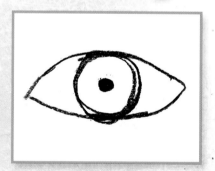

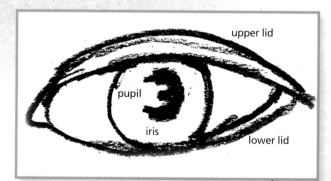

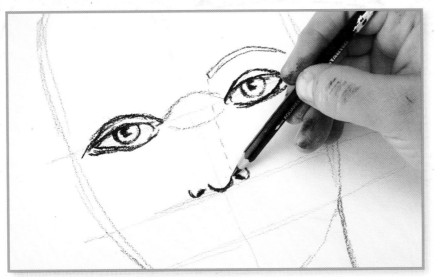

7 The tip of the nose goes on the nose (one-quarter) line. I find people struggle with the nose more than any other feature. The nose can be tricky because of its volume. It's like a pyramid sitting on your face. In order to make it look real, you need to add shading and shadowing. When you're drawing, keep the nose simple. I often describe it as the handlebars of a bicycle. And remember, remember, remember that the eyebrows connect to the TIP of the nose, not to the side of the nostrils.

Nose Tip

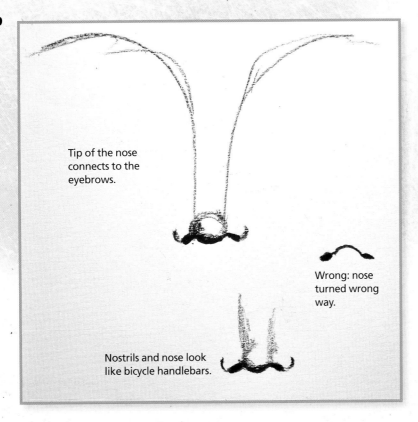

Tip of the nose connects to the eyebrows.

Wrong: nose turned wrong way.

Nostrils and nose look like bicycle handlebars.

Visit **CREATEMIXEDMEDIA.COM** to sign up for the free newsletter!

39

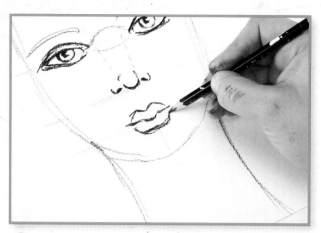

8 The mouth goes on the mouth (one-eighth) line.

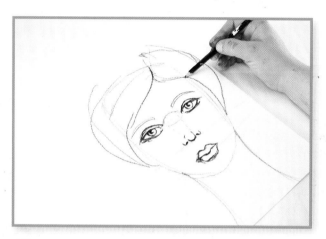

9 Draw in the hair. A common mistake is to draw in too much hair, or to try to draw every strand. Just draw in the suggestion or overall shape of a hairstyle.

Lip Tip

Often beginners tend to draw clown lips, like this:

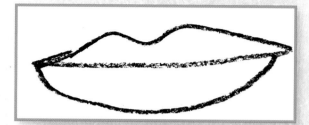

Clown lips look unnatural. No one has lips like that except the Joker!

Touch the center of your top lip. Do you feel that fleshy little bump? Lips that you draw will look more realistic if you draw in that little fleshy bump. The bottom lip can be rounded or a bit square, and it doesn't extend to the very edge of the mouth.

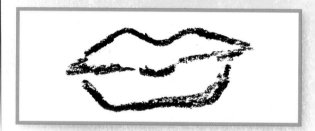

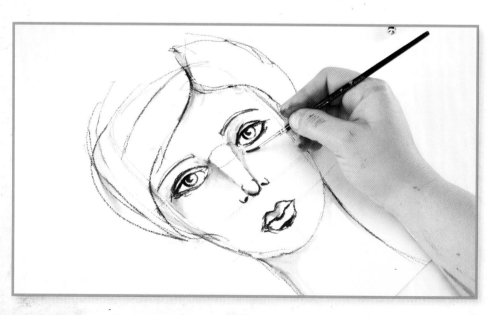

10 Wet a paintbrush and go over some of your Stabilo All lines to dissolve them. You can pull some of the pencil marks outward using the brush to shade and create visual interest.

Visit CreateMixedMedia.com/art-journal-courage for bonus downloads and more!

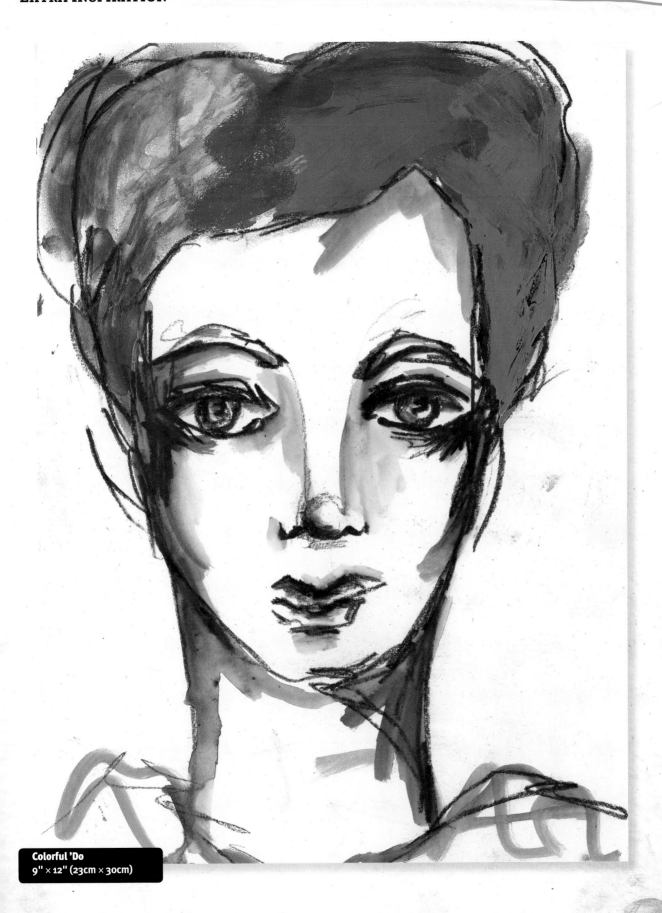

Colorful 'Do
9" × 12" (23cm × 30cm)

Visit CREATEMIXEDMEDIA.COM to sign up for the free newsletter!

41

Painting the Portrait

Now that you're getting comfortable with drawing, let's add painting. I love to paint the faces that I draw with bold brushstrokes and expressive colors.

The formula for painting is an exercise in shadows and highlights. As long as your shadows and highlights are in the right place, you can get away with all kinds of crazy colors.

The placement of shadows and highlights varies depending on which way light is shining on the face. For example, if light is coming in from the side, one half of the face will be much lighter than the other. We'll practice as if light is coming from the front.

You will need a shadow color, a highlight color and a base color. I like to use Umber for shadows and white for highlights. For a base color, I mix a little bit of primary red, yellow and blue. This combination makes brown. Then add white paint until you have the skin tone that you want. If the color is a little too pink, add more yellow or blue. If it's too purple, add more yellow. Keep tweaking and adding bits of color until you are happy with the color you've created.

Keep in mind, though, that you don't have to paint your faces with a realistic skin tone. I've been known to paint faces pink or blue or even green. Make it fun!

I like to use a small bright or flat brush to paint with. I start with a dry brush and I do not wash the brush in between colors. That way the paints blend together as I go. You may find yourself painting in the shadows and highlights multiple times. That's the way it works.

MATERIALS

a face you've drawn (I like to draw over a painted background)

acrylic paint (Titanium White, Umber, pink, yellow)

gesso

Neocolor II crayons or Stabilo Woody pencils

paintbrushes (I like to use a small bright or flat)

spray inks

Stabilo All pencil

stencil

your journal

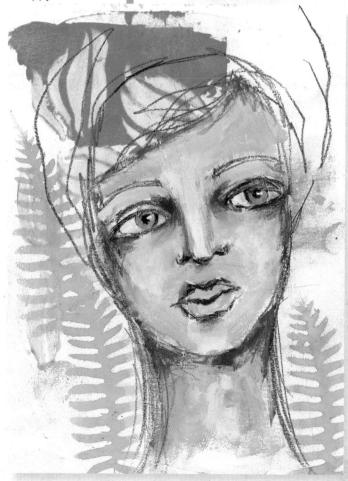

42

Visit CreateMixedMedia.com/art-journal-courage for bonus downloads and more!

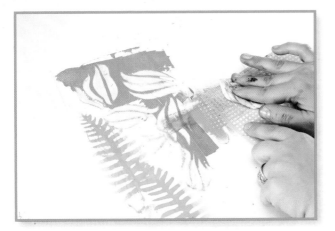

1 Gesso a page in your journal and let it dry. Create a basic background by using the techniques shown in the Tracing to Train Your Hand demonstration.

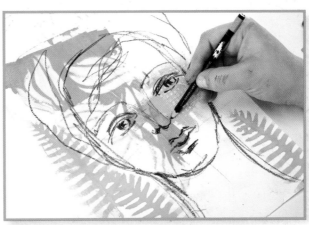

2 Draw a face on the background using a Stabilo All pencil.

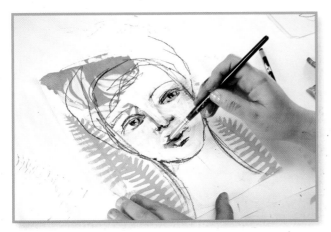

3 Use Titanium White to paint a base for the entire face. This removes the background from your sight and makes it a little easier to paint the facial features. Confession: I don't always paint in a base, often I just start with shadows. But when you're just starting, it's good practice to paint a base in the face. I don't go all the way to the edges of my drawing. I like the background to peek through. If you're using the Stabilo All pencil and your paint to the edges of your drawing, you'll blur out the pencil lines. Try to get near them but don't cover them.

Keep It Light

Leave white space in your background to make it easier to draw over. Also avoid making the background too dark. You need your pencil lines to show.

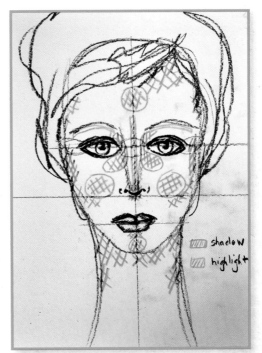

4 Decide where highlights and shadows go. In the diagram, the green is where the shadows go and the orange is where the highlights go. Highlights will be where the face protrudes most. Shadows are where the face recedes.

Visit CREATEMIXEDMEDIA.COM to sign up for the free newsletter!

43

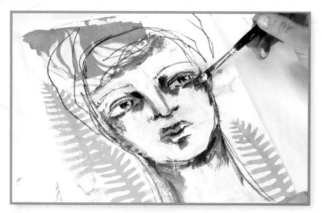

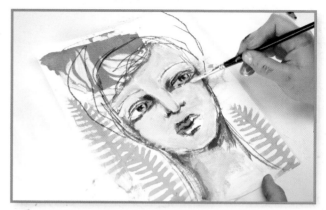

5 Paint in shadows with Umber. Don't be hesitant. When in doubt, shade more than you think you need. My most-used comment in class is, "Be more aggressive with your shading."

6 Mix a base color by mixing a small amount of pink and yellow paint with a larger amount of white paint. If you'd like the face color to be more brown, add Umber. (I also like to mix a bit of primary red, primary yellow and primary blue with white paint to create a lovely skin tone.)

Use the base color to paint the whole face, including a bit of the shadows. Don't cover the shadows completely. Overlap the shadows and leave them peeking through. If you work fast and don't wash your brush, the shadows will blend into the base at the edges.

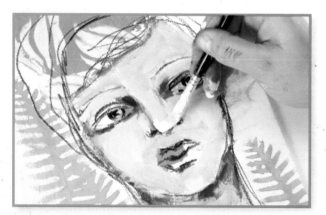

7 Use white paint to paint in the highlights. Again, by not cleaning your brush you don't get super-white highlights, instead you get a lighter version of your base color. At any point, if you cover up too much shadow, just paint it back in (same goes for base color and highlights). Keep working with shadows, highlights and base color until you're happy with the face. Sometimes you may have to repeat the steps multiple times until you get the face looking the way you like.

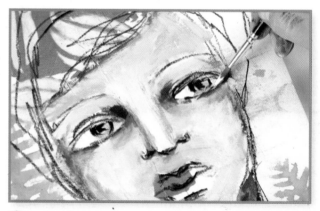

8 Paint Titanium White in the whites of the eyes. Also paint white where the catchlight goes in the pupil. The catchlight is not a big white dot. It is a small oval or rectangular mark in the pupil. It may overlap the iris.

Blending in the Brush

I don't wash my brush at all during the face painting process as I move from shadow to base color to highlight color. That way the paint blends on the brush and on my work as I go.

Visit CREATEMIXEDMEDIA.COM/ART-JOURNAL-COURAGE for bonus downloads and more!

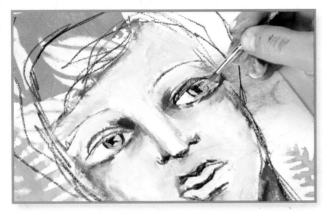

Hair Is Optional

If you want to add hair color feel free, but I like the background that's here instead of hair.

9 Give the eyes an eye color with a few strokes of paint in the iris of the eye. Make sure your pupil is very, very dark black. Use your pencil to reinforce it or use a bit of black paint.

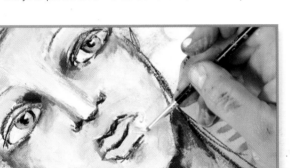

10 Paint the mouth pink or beige. Keep in mind there are areas of the lips that protrude and therefore have a highlight (usually the fleshy bump and the center of the bottom lip). To create a nice lip color, add a bit more pink to the flesh tone you mixed for the face.

EXTRA INSPIRATION

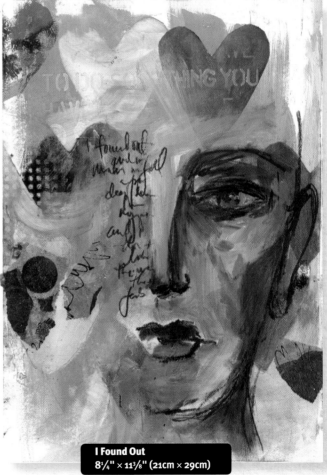

I Found Out
8¼" × 11⅜" (21cm × 29cm)

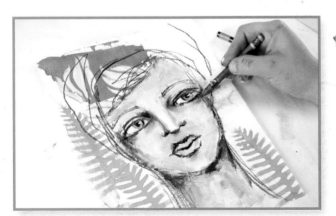

11 If you have painted over any of your black lines, put them back in with your pencil after you paint. I find my faces always look better after I redraw lines that I have painted over. Use Neocolor II crayons or Stabilo Woody pencils to add pops of color and interest to your face. Scribble away!

Visit CREATEMIXEDMEDIA.COM to sign up for the free newsletter!

45

Courage to Include You

Fear: I don't want to, or know how to, include my image in my work.
Courage: Examining yourself is a time-honored artistic tradition that helps you learn and grow as an artist.

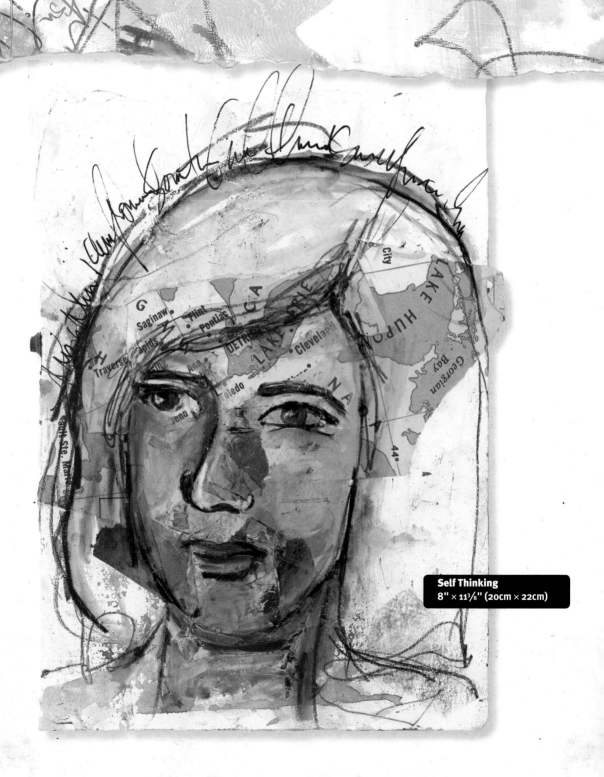

Self Thinking
8" × 11⅜" (20cm × 22cm)

Visit CreateMixedMedia.com/art-journal-courage for bonus downloads and more!

Who are you?

That's one of the questions that art seeks to answer. Artists explore who they are, where they came from, where they are going. One of the ways artists explore this question is by using their own image in their work by creating self-portraits. When you use *you*, your art becomes intimate, revealing and introspective. Inherent in the process of art journaling is the process of discovering yourself, reinventing yourself and making sense of yourself. So what better image to use in your art journal than *you*?

Self-portraits have existed as long as there have been artists who create. Michelangelo inserted himself into his work several times (look for his face in the Sistine Chapel). Van Gogh painted at least thirty-five self-portraits. Rembrandt made more than ninety. The vast majority of Frida Kahlo's work includes her image. Andy Warhol used his image hundreds of times.

In the age of the overabundant selfie, I know that some find self-portraits indulgent and narcissistic. I disagree. To me, self-portraits show self-reflection—a willingness to examine what is on the inside as well as what is on the outside. Self-portraits are your own personal mark upon the world, a mark that only you can make.

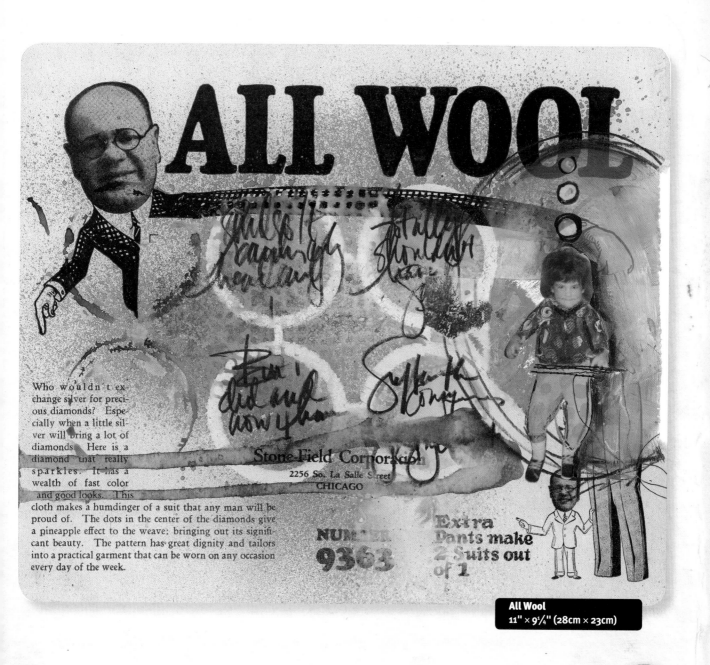

All Wool
11" × 9¼" (28cm × 23cm)

Visit CREATEMIXEDMEDIA.COM to sign up for the free newsletter!

47

Taking Self-Portrait Photos

To use images of you in your journal, you first need some pictures of you. Once you have a few pictures, you can do the techniques in this chapter. I don't claim in any way to be a photography expert or a self-portrait expert. I sure take a lot of mediocre pictures of myself. However, I will give you a few tips on taking self-portraits. You can always hand the camera over to someone else and she can take a few shots. I do want you to try taking a few yourself, though. When you capture your own image, you have total control over the process. I find I'm more comfortable taking my own picture than I am with someone in the room with me, putting the camera in my face. I can be more natural (or goofy, or moody) by myself.

TIPS:

- Use a tripod and your camera's self-timer. You can only take so many pictures by holding your camera out with an extended arm. If you don't have a tripod, balance your camera on a stable surface.
- Seek out natural light. I often take self-portraits by my studio window. I face the window so the light is on my face, and then I shoot. Try going outdoors on a cloudy day, or seek any natural indirect light.
- Take lots of shots. Take fifty or one hundred (or more) in one session, and you might get one or two good shots. That's just how it goes. As you shoot, vary your position, expression, etc.
- Take pictures of yourself at different times of day and in various settings and emotions. Take a picture of yourself when you get up, when you go to bed, after you get out of the shower, when you're crying, when you're happy, when you're waiting to pick up kids from school. I often take pictures of myself in the morning because I have legendary bed head. Even my eyebrows are in knots in the morning. I've taken some great "I hate mornings" self-portraits.
- Change camera angles. Take shots from above, below, behind … you name it. I tend to hold my camera up and to the left, since that's my "good side" and looking upward into the lens helps eliminate my double chin. It's fine to shoot your good side, but try some other angles as well. Try taking some shots where you're not looking into the camera, too.
- Use a webcam to snap photos of yourself. I love to take self-portraits with my webcam. I don't have to drag out my big camera, and I can take pictures of myself in the true moment of the day: awake, asleep, grumpy, in pajamas, dressed up. My webcam shots are some of my favorites because of the little slice of life they capture.
- Take a photo every day or week at the same time, in the same place. Why not?
- Take photos of all of you. A self-portrait doesn't have to be of your face. Photograph your hands, your feet, etc.

Now that you have some good photos to work with, let's make art.

Create a Stencil of You

This technique is simple but produces a striking effect. We're going to take a photograph of you and make a stencil out of it. To make the stencil easy to cut, I like to alter the photograph a bit with photo-editing software. If you don't have the software, you can still cut a stencil from a photograph. You'll just have to observe your photo carefully to figure out where to cut. When your stencil is done, you can use it as a focal point or in backgrounds.

MATERIALS

a photograph of you

Adobe Photoshop®, Photoshop® Elements or another software editing program

baby wipe

black and hot pink spray paint

black pen

craft knife

cutting mat

Dylusions Ink Sprays in Bubblegum Pink, Funky Fuschia and White Linen

Fineline applicator bottle containing teal paint

gesso

sheet of white cardstock

stencils (leaf, star, chevron mosaic)

water spray bottle

your journal

your printer

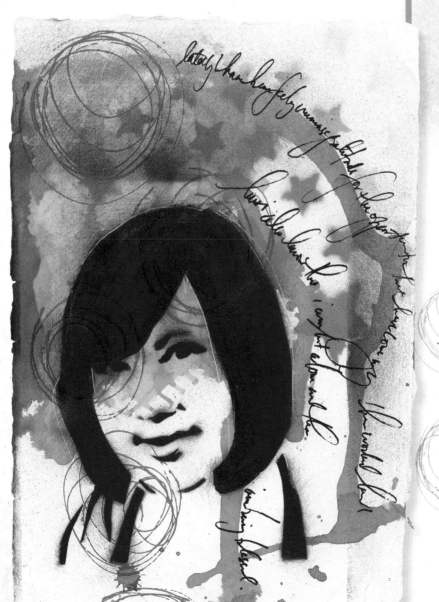

1 Choose a photograph of you and open it in your photo-editing program. These instructions work for Adobe Photoshop and Photoshop Elements. You can research your software program's features to find a similar setting.

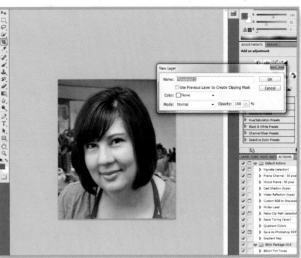

2 Choose Layer > New Adjustment Layer > Threshold. Click OK when the box appears.

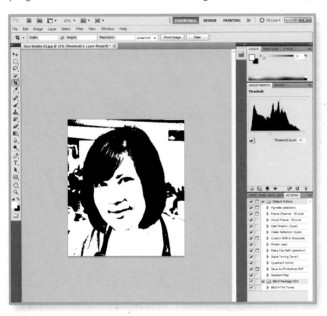

3 Use the slider on the right to adjust the level of black in the photo. You want to have enough black to see your features but not so much that the photo is noisy with distracting black areas.

Save and print your photo. You may want to print it on cardstock to create a more durable stencil.

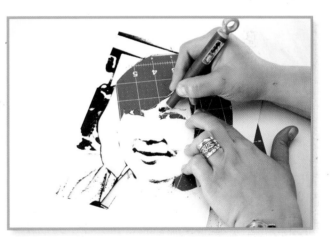

4 Use your craft knife to cut out the black areas of your features in the photo. You are not trying to achieve lots of detail. Just cut the general shape of your eyes, nose and mouth. Don't forget your hairline, chin and maybe part of your clothes. As you are cutting, flip the cardstock over now and then to look at what the cuts look like without the distraction of the printed photo. You'll get an idea of how the finished stencil will look.

No Teeth Please

It's best to choose an image in which your head fits the whole frame of the picture and your mouth is closed (teeth can be hard to deal with in a stencil).

Visit **CREATEMIXEDMEDIA.COM** to sign up for the free newsletter!

51

5 Gesso a page in your journal. Puddle some Bubblegum and Funky Fuchsia ink on the page.

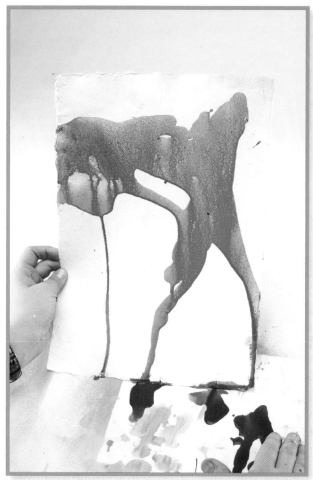

6 Spray some water into the puddle and lift your journal so the puddle runs and drips.

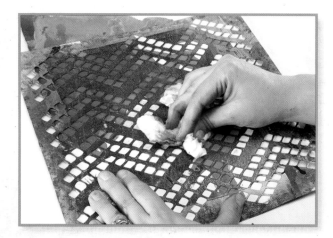

7 Lay down a mosaic chevron stencil and rub over the inky area with a baby wipe.

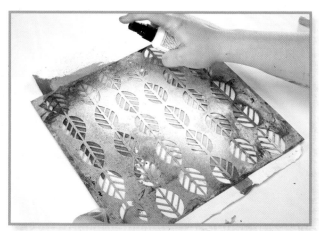

8 Lay down a leaf stencil and spray through it with White Linen ink.

Visit **CreateMixedMedia.com/art-journal-courage** for bonus downloads and more!

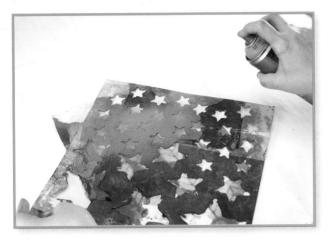

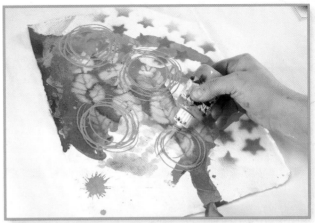

9 Lay down a star stencil and spray through it with hot pink spray paint. When you use spray paint, it's important to spray in a ventilated area or outside.

10 Draw large, scribbly circles on the page with the teal paint in the Fineline applicator bottle. Let the page dry.

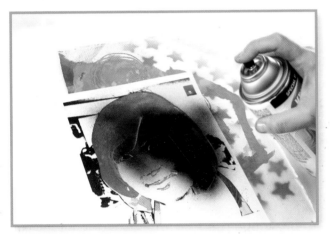

11 Lay down your custom stencil and spray through it with black spray paint.

EXTRA INSPIRATION

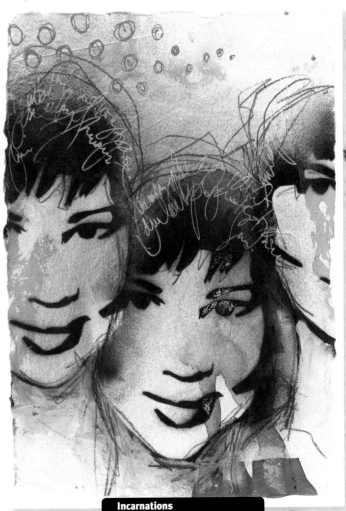

Incarnations
10½" × 14¾" (27cm × 37cm)

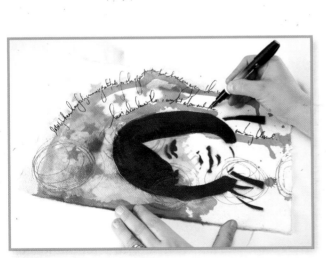

12 Add journaling on the inky drips.

Visit CREATEMIXEDMEDIA.COM to sign up for the free newsletter!

53

Altering Photos

There are many ways to alter photographs (some books center on this subject alone). This technique is my most-used method. We're going to use a photograph of you (I used a photograph from my childhood), and then draw and paint over it to incorporate it into the page.

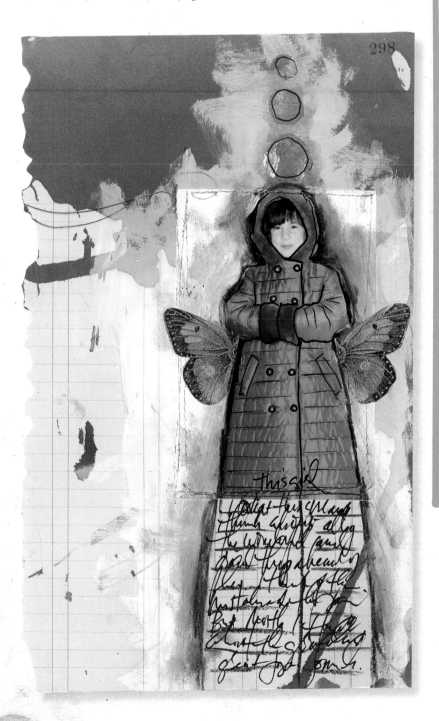

Visit CREATEMIXEDMEDIA.COM/ART-JOURNAL-COURAGE for bonus downloads and more!

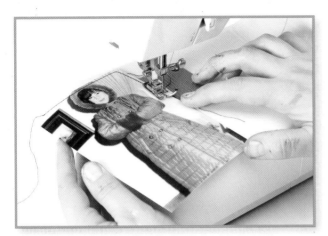

1 Sew around your photograph to create a border.

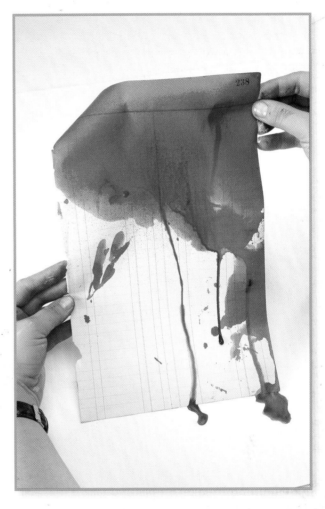

2 Puddle Funky Fuchsia ink at the top of your page, add water and lift your journal to let the ink drip down the page.

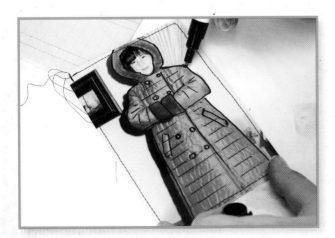

3 Use a black paint marker to outline some areas of the photograph. I outlined the coat I was wearing, including some of its details.

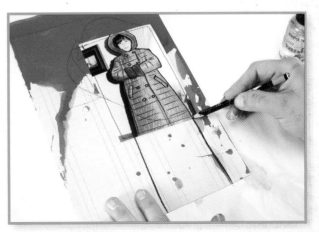

4 Glue your photograph to the paper you chose using a gel medium. Use your Stabilo All pencil to add to the photograph. I made the coat extend down to the very bottom of the page.

Visit CREATEMIXEDMEDIA.COM to sign up for the free newsletter!

55

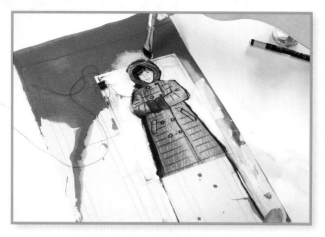

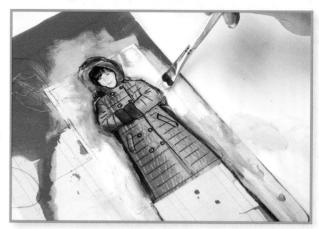

5 Paint around the figure in the photo (you!) with white acrylic paint.

6 Scribble around the edge of you with the Stabilo All pencil, and then use your paintbrush and a bit of white paint to dissolve the scribbles and blur them out. This creates shading.

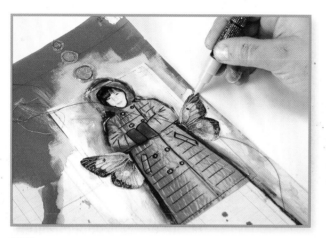

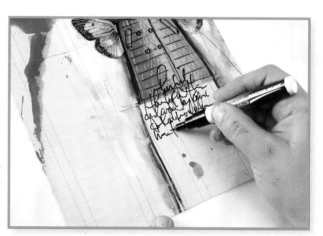

7 Glue bits of painted paper near the figure to create interest and draw the eye. I used three circles cut from painted deli paper. Glue on any other collage bits you want. I used a clip art butterfly, cut in half, and glued it on either side of my coat.

8 Use a black pen to add journaling.

9 Add a pop of color! I used a bit of yellow paint to contrast with the ink.

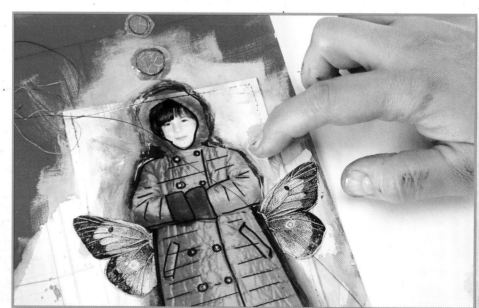

Visit CreateMixedMedia.com/art-journal-courage for bonus downloads and more!

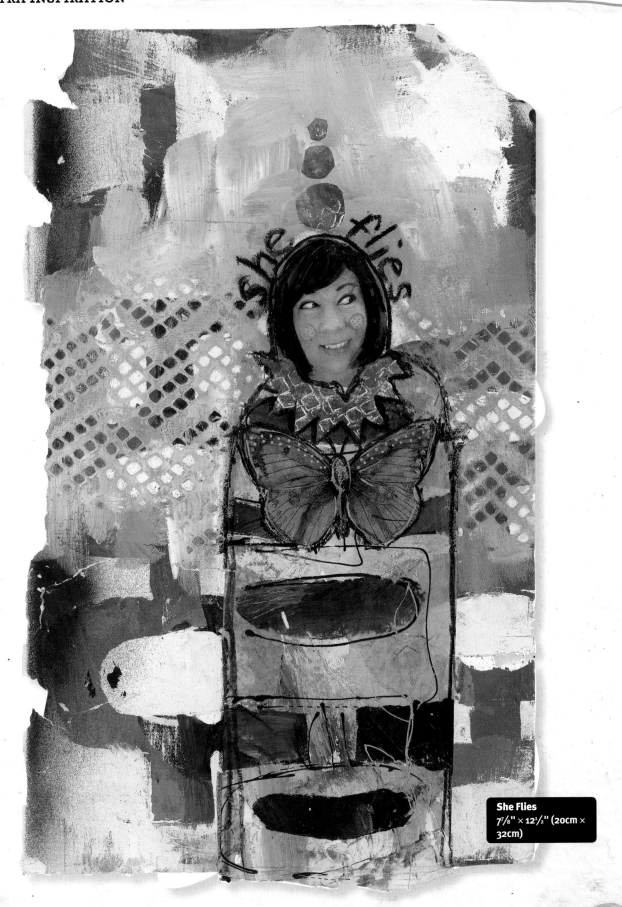

She Flies
7⅞" × 12½" (20cm × 32cm)

Visit CREATEMIXEDMEDIA.COM to sign up for the free newsletter!

57

Painting Over a Photograph

I love to paint over photographs. This classic technique has been around for years. It gives you a great artsy image for your journal, and it also is great painting practice. I find it easiest to paint over photos that are close-ups, and I like my mouth to be closed. (I'm not too good at painting my teeth; they tend to end up looking a bit like Chiclets.)

MATERIALS

acrylic paint

black Stabilo All pencil

color-copy of a photograph (not an ink-jet print)

gel medium

paintbrushes

Portfolio Oil Pastels or Neocolor II crayons

scissors

stencil

water

white cardstock

white pen

your journal

your printer

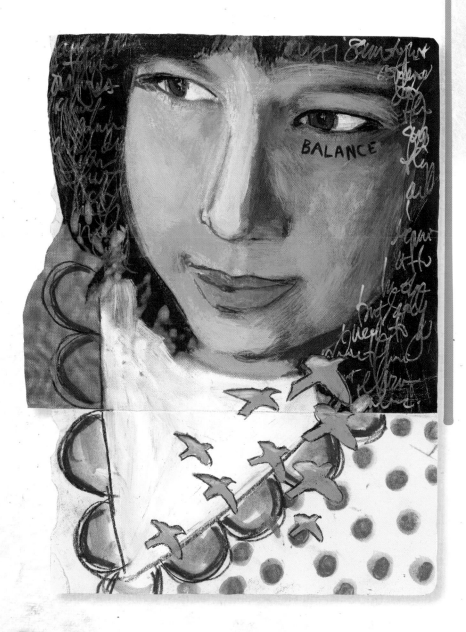

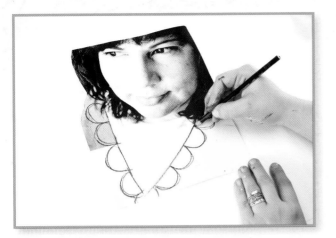

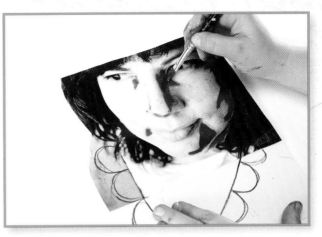

1 Select a photo of you, print it on white cardstock, cut it out and glue it onto a journal page using a gel medium. Add any details you wish to the photo to integrate it on the page. For my sample, I created a shirt with a collar.

2 Look at your photo carefully. Do you see areas that are light (highlights) and areas that are dark (shadows)? We're going to take cues from the highlights and shadows on the photo. The cues will tell us where to put certain colors.

First, take a look at the shadows. Take some Umber (or another dark color, like Night) and paint it over the dark areas.

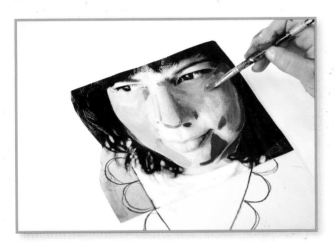

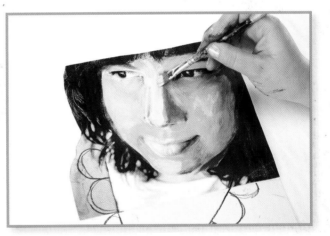

3 Pick a color for the face. (See the section on painting portraits for tips on mixing a face color.) Paint a transparent layer of the face color over the face, and as well as the highlights and shadows that you previously painted. I typically paint over everything except the eyes. Keep this layer transparent so you can still see the nuances of the photo underneath.

4 Put some white paint on the highlights of your photos. In my sample, I put some white paint on and then used some water to blend it into the photo.

A Delicate Balance

If your image is copied onto regular paper, the moisture will cause some buckling. Try to keep your paint transparent without adding too much water. It's a delicate balance.

Visit CREATEMIXEDMEDIA.COM to sign up for the free newsletter!

59

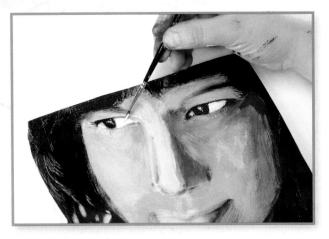

5 Paint the whites of the eyes.

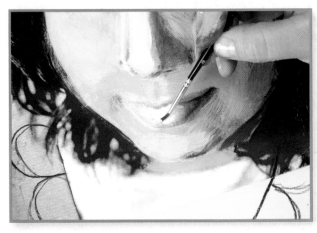

6 Paint the lips white for a base coat.

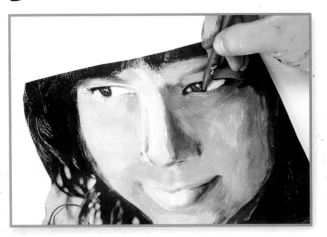

7 Use a Neocolor II crayon to color the eye.

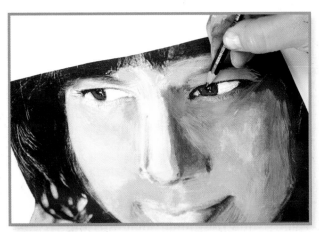

8 Add little details for the eyes, like the pupil, while retaining the catchlight and the outline of the eyelids.

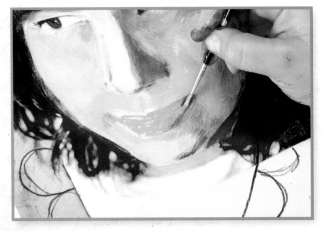

9 Add a bit of red paint to the skin face color you used earlier. Loosely paint the lips.

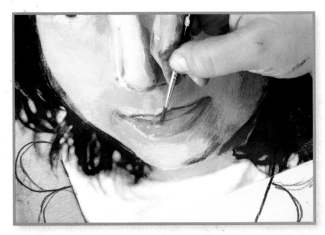

10 Add a darker color around the outline of the lips.

Visit **CreateMixedMedia.com/art-journal-courage** for bonus downloads and more!

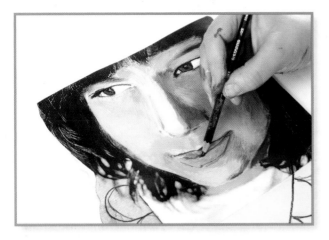 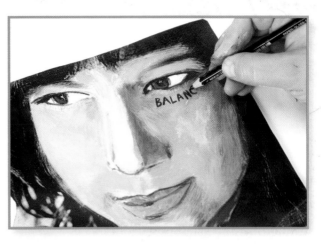

11 Use a black Stabilo All pencil to paint the fleshy bump where the upper and lower lips meet.

12 Add some journaling near the eye.

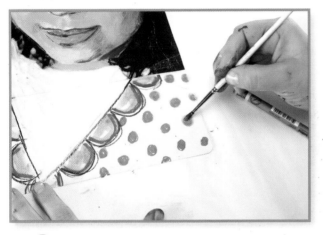 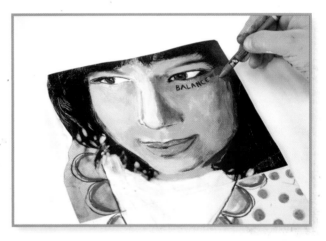

13 Color the collar and make a pattern on the shirt with a Neocolor II crayon. Use water to activate the Neocolor.

14 Add some nontraditional face colors to add interest to the face.

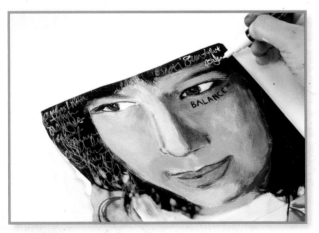 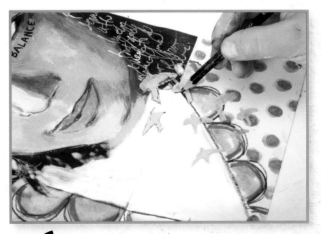

15 Use a white pen to add journaling in the darkest areas of the photo.

16 Stencil or draw a design over the edge where the photo is glued to the journal page to join the two together. Outline the design with a Stabilo All pencil.

Visit CREATEMIXEDMEDIA.COM to sign up for the free newsletter!

61

Using Your Silhouette

The human silhouette is a powerful image. It's one of my favorite motifs. A silhouette is interesting because it is both a presence and an absence. Is the person there, or is there a void? So powerful. Why not use your own silhouette in your work? Don't worry about your size or shape. You are who you are, and who you are is beautiful. Choose a photo of yourself that is your whole body (or at least the knees up).

MATERIALS

- alphabet stamp set (mine is by Stampotique)
- black Archival ink pad by Ranger
- black permanent pen
- glue
- ink sprays by Dylusions in Tempting Turquoise, Pure Sunshine, White Linen and Bubblegum Pink
- Neocolor II crayons or oil pastels
- old book paper
- paintbrush
- picture of you, from the knees up (or full length)
- red paint marker
- scissors
- sewing machine
- stencils
- white acrylic paint
- your journal
- your printer

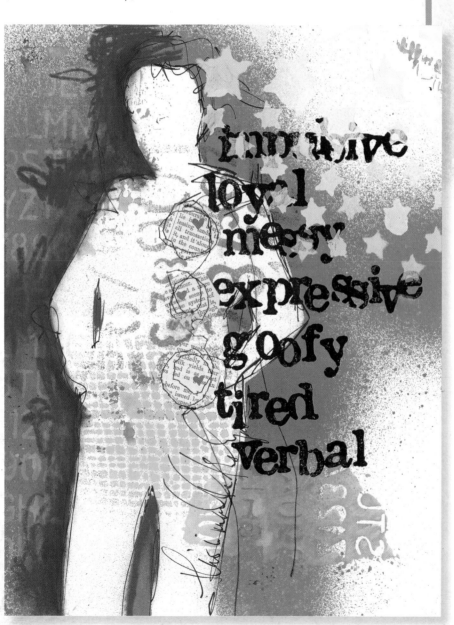

Visit CreateMixedMedia.com/art-journal-courage for bonus downloads and more!

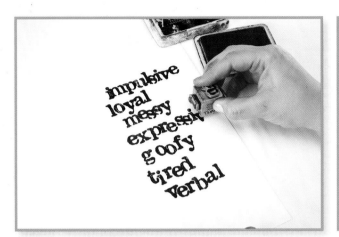

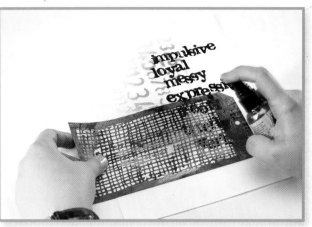

1 On your journal page, use black Archival ink and the alphabet stamps to stamp a list of adjectives that describe *you*. I included some of my positive and negative traits to portray a true version of myself.

2 Use two stencils and two colors of ink to spray some background texture onto your background. I used pink and orange spray inks.

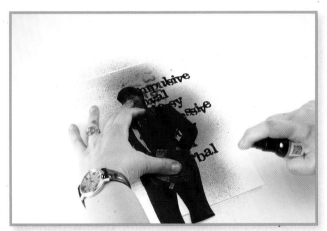

3 Print out a picture of you and cut a silhouette around yourself. I find that sometimes my hair gets in the way of the silhouette looking good, so I often cut off most of my hair.

Lay your silhouette over the sprayed texture and spray around it with Tempting Turquoise ink spray. Ink the area around the silhouette well and keep your hand moving so the ink doesn't seep under your mask.

An Appealing Silhouette

As you cut the silhouette, flip it over and look at it from the reverse side. This will give you a good idea of the shape the silhouette will be on your page, and you will see if you need to trim off hair or make other adjustments. Your silhouette will look best if your arms are slightly away from your body.

Visit CREATEMIXEDMEDIA.COM to sign up for the free newsletter!

63

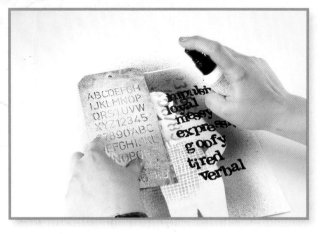

4 Use White Linen spray ink and a stencil to add some background stenciling to the turquoise areas.

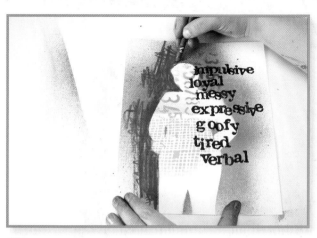

5 Choose a turquoise Neocolor II crayon or oil pastel and color around the left side of the silhouette. You're creating shading by using tone-on-tone color.

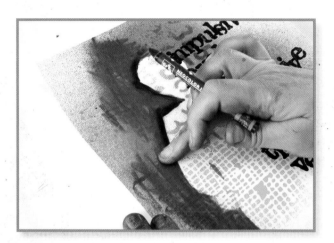

6 Add some shading with a black or gray crayon as well. This gives your silhouette more definition and depth. Use your finger to smudge out the crayons.

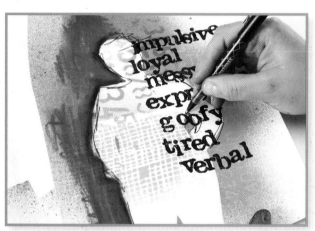

7 Outline your silhouette with a black permanent pen. Use loose, messy lines instead of trying to outline it precisely.

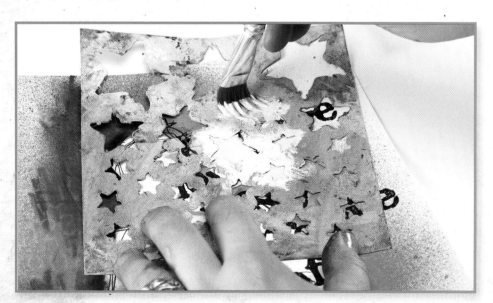

8 Use white acrylic paint and a dry brush to add some stenciling to the top right of your page.

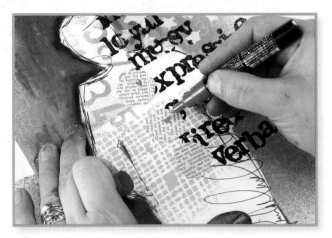

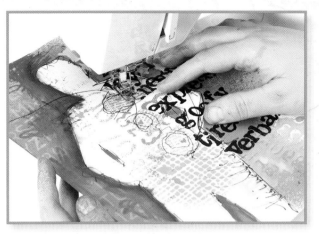

9 Add any extra writing or journaling that you would like to the page. Glue down three book page circles. Use a red paint marker to add hearts to the three text circles.

10 Sew around the circles with your sewing machine. I can actually fit my journal under my machine! If you can't fit your journal in your machine, sew on the circles before you glue them down so you still get the sewn look.

EXTRA INSPIRATION

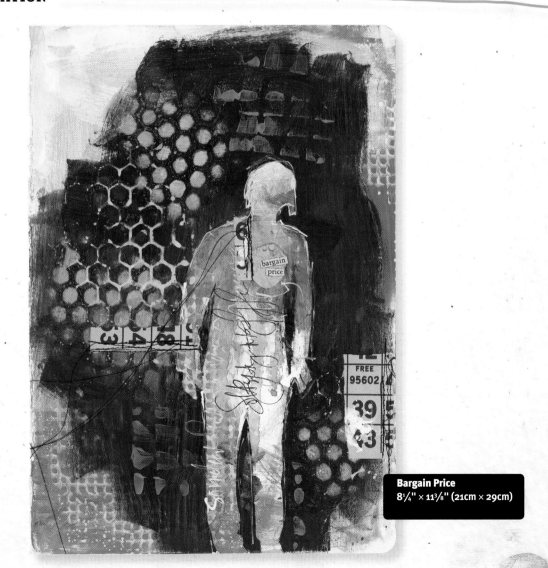

Bargain Price
8¼" × 11⅜" (21cm × 29cm)

Visit **CreateMixedMedia.com** to sign up for the free newsletter!

65

Courage to Layer

Fear: Layering is hard. I don't know what to do next.
Courage: Breaking down the layering process into tools and methods will help you layer with confidence.

Layering can be intimidating. It's easy in theory (just put lots of stuff on the page), but in reality layers can get out of hand quickly. They can be hard to control and easy to overdo.

There are two keys to understanding layering: First, you must understand your media and how it works, and second, you must think of layering as if it were a pyramid. Also keep in mind that all of the color and composition principles from my first book, *Art Journal Freedom*, are at play.

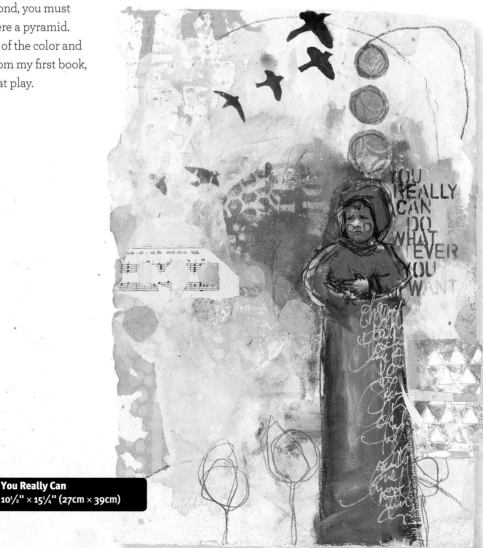

You Really Can
10½" × 15¼" (27cm × 39cm)

Visit CREATEMIXEDMEDIA.COM/ART-JOURNAL-COURAGE for bonus downloads and more!

Know Your Media

A common layering mistake that artists make is to combine different media that don't work well together. For example, I've seen people frustrated in class because they spray lots of ink on their page and then when they paint over those areas, the ink bleeds through. You can prevent these frustrations by understanding the properties of your favorite inks, paints and other art supplies. Try making a chart of your favorite items. Here are mine:

Media Type	Properties	Great for . . .	Be Aware of . . .
Dylusions Ink Sprays	Nonpermanent. Reactive with water. Vibrant colors.	Plain paper. Foundation layers. Bits of pattern and texture over paint. Drips.	Will react with anything wet (paint, water, modeling paste). Will bead up and be lighter over acrylics (don't blot them over acrylics).
Gesso	Necessary for using acrylic paint: When used over a gesso layer, paint won't soak into the paper and it will be the proper color and have proper spreading abilities.	Foundation layers. Top texture. Anytime you need transparent white.	Is stickier than regular paint.
Acrylic paint	Dries quickly. Cleans up with water. Acrylic paint = plastic.	Color! Backgrounds, middle, top layers.	Can paint over anything water based. Doesn't go great over oil. Paint opacity varies wildly over colors and brands.
Oil pastels	Will write on almost anything. Smooth, blendable. Opaque (generally).	Top layers. Resist techniques.	Can't write with a pen over oil, so oil needs to be one of your last layers. Will resist anything water-based. Hard to paint over.
Neocolor II crayons	Will write on almost anything. Water soluble. Opaque.	Color! Backgrounds, middle, top layers. Adding pops of color and drawing over paint.	Can be difficult to write over.

Visit CREATEMIXEDMEDIA.COM to sign up for the free newsletter!

67

Media Type	Properties	Great for . . .	Be Aware of . . .
Stabilo All pencil	Will write on anything. Water-soluble.	Drawing over paint.	Is water-soluble so will move when anything wet gets near it. Can remove it with a baby wipe or wet rag. Sometimes I fix my page with Workable Fixatif after I use this pencil.
Regular pencil	Erasable, to a degree.	Drawing, scribbling, doodling.	Will give a light line on paint.
Pens (permanent, such as Fude Ball 1.5, Sharpie Water-based Paint Marker, Faber-Castell PITT)	Nice black or white line for journaling. Permanent when ink is dry.	Adding journaling, drawing, doodling. Foundation and middle layers.	Won't write over oil or Neocolor. Can be tricky to write over textured layers.
Modeling paste	Sandable. Paintable. Flexible. Noncracking.	Adding texture and dimension.	Hard to write or stamp over.
Archival ink pad by Ranger	Oil-based dye ink. Permanent when dry.	Stamping onto acrylic paint or colored backgrounds.	Will stain stamps.
Gel medium	Matte or glossy, depending on type. Dries flexible.	Great collage glue. Great for image transfers. Can add to acrylic paint to give it more body and texture.	Don't write or sew on it until it's completely dry. Will resist watery paint or ink to a degree but you can paint over it with heavy body or thick paint.
Beeswax	Transparent. Must be melted (iron, melting pot, skillet, heat tool).	Adds a floating quality to collage. Great top layer.	Can't write over it.
PanPastels	Artist pigment pastels. Erasable. Low dust. Blendable.	Great backgrounds. Stamp with Watermark pad and brush PanPastels over image for a tone-on-tone look. Can draw, paint, etc. Can write on them, stamp on them, draw on them.	May not work on top of acrylic.

The Layering Pyramid

I like to think of layering like a pyramid. When you first start a page, you are at the bottom of the pyramid. Anything goes for these first layers, which I call foundation layers. You can paint, scribble, stamp, you name it!

Once your foundation layers are down, you have to make an informed choice about what comes next. Every choice you make for a layer affects the next choice you can make. For example, if you've used lots of oil pastel in your foundation layers, it probably isn't wise to paint over it with acrylic (since acrylic doesn't go well over oil). This is why it's essential that you understand your media and its properties.

Top Layers
Small layers that lead the eye, add visual interest and provide unity and rhythm.

Middle Layers
Read your foundation layers and make informed choices. This is where the meat of your page is (images and journaling).

Foundation Layers
Anything goes in the background.

After I do my foundation layers, I "read" them and start adding middle layers. These middle layers don't cover as much area as the foundation layers (as we move up the pyramid, layers tend to get smaller and cover less area).

I find that my focal point and my journaling usually come into play in my middle layers. If you don't know what color to add next, choose another version of a color that's already in your piece. Or try a neutral.

Once the middle layers are down, I add my top layers. Now we're at the very top of the pyramid, so these top layers cover even less area than the middle layers. Top layers can include top texture, pops of color to draw the eye, and doodles and lines. Keep in mind what works in the background may not necessarily work on the top layers. For example, a watery wash of ink works well in a background but not as a top layer.

Review Color Theory and Principle of Proximity

Design principles and color theory can help guide your layers (explained in my first book, *Art Journal Freedom*). Are your layers turning muddy? It's because of your color choices. Are your layers jumbled and visually unappealing? Review the principle of proximity.

Visit CREATEMIXEDMEDIA.COM to sign up for the free newsletter!

69

Have a Media and Technique Tool Kit

All of the art techniques you know are in your "layering tool kit." When you are working in your journal and want to add a new layer, dig around in your tool kit and choose a new technique or media to use. Ideas can include:

- Texture in wet gesso
- Layering papers under gesso
- Paint or ink drips
- Paint spatter
- Palette knife painting
- Sgraffito
- Raised stenciling
- Plastic wrap texture
- Imbedding objects in gesso
- Monoprinting with unique texture tools
- Collage
- Drawing
- Doodling
- Top texture (white or black through a stencil or with a texture tool)
- Painting
- Spray inking
- Stenciling with modeling paste
- Stenciling with paint
- Stenciling with ink
- Tracing through a stencil
- Beeswax/encaustic
- Stamping
- Scratching
- Sanding
- Journaling
- Image transfers
- Tapes
- Oil pastels
- Chalk pastels
- Crayons
- Gelatos pigment sticks
- Acrylic inks
- Charcoal
- Colored pencils

- Glazing
- Sewing, embroidery
- Plaster
- Spray paint
- Masking
- Silhouetting
- Tracing
- Adding fabrics
- Many more!

Flying
8¼" × 11⅜" (21cm × 29cm)

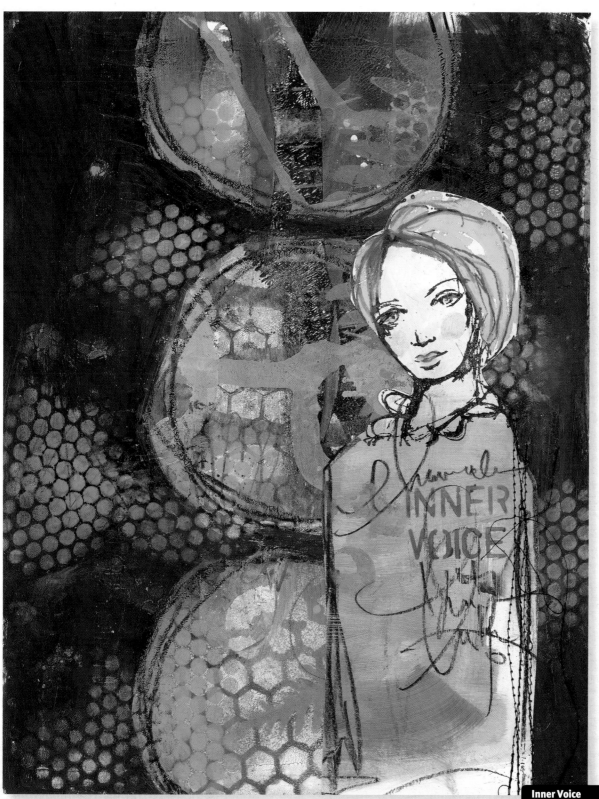

Inner Voice
8½" × 11" (22cm × 28cm)

Visit CreateMixedMedia.com to sign up for the free newsletter!

71

Layering Method

Let's layer! I teach a class where I have students put twenty-five layers on a page. They panic initially but eventually get in the groove when they see that a layer can be as simple as a polka dot. Anytime you change your color or use a different mixed-media technique, or pick up a different medium, you are starting a new layer. As you create, keep in mind your foundation, middle and top layers.

MATERIALS

acrylic paint (pink, yellow, violet, Titanium White, Payne's Grey, teal, turquoise, blue)

baby wipes

black pencil, Lyra Color Giant

Fineline applicator bottle filled with black fluid paint

gesso

ink spray in orange

matte gel medium

Neocolor II crayons

old book page

old gift card

paintbrushes

piece of sticky-back canvas

red paint pen

scissors

Stabilo All pencils in black and white

stencils

vintage photo

your journal

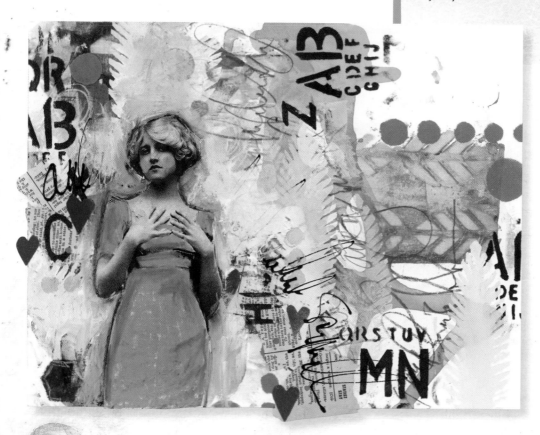

Visit CreateMixedMedia.com/art-journal-courage for bonus downloads and more!

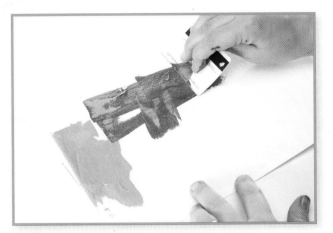

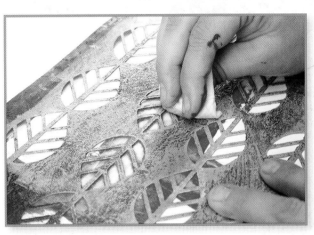

1 Gesso a page in your journal and let it dry. Scrape some pink and yellow acrylic paint onto your page using an old gift card.

2 Lay down a stencil and rub through it with a baby wipe to remove some of the paint.

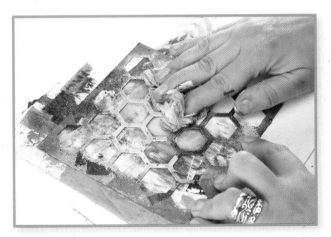

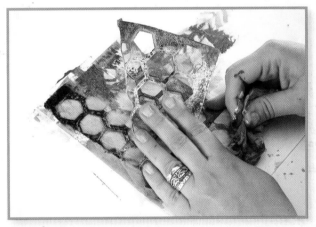

3 Scrape some violet paint onto the page and repeat the stenciling and rubbing. Use the same stencil, then switch to a new one.

4 Scrape some Titanium White paint and some Payne's Grey paint onto the page, and repeat the stenciling and rubbing.

Overlap Your Colors

Vary the placement of your colors but make sure they overlap at least 30 percent. If you don't overlap the colors, it will look like they are floating near each other instead of layering each other. If there is no overlap, there is no layer.

Visit CREATEMIXEDMEDIA.COM to sign up for the free newsletter!

73

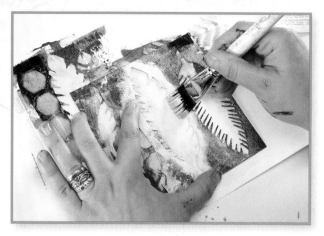

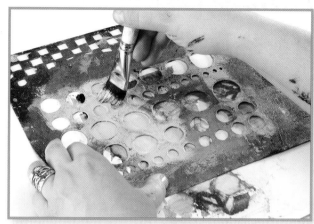

5 Choose a stencil and stencil through it with a dry brush and white paint. Put the paint on several areas of the page.

6 Choose another stencil and stencil through it with teal paint.

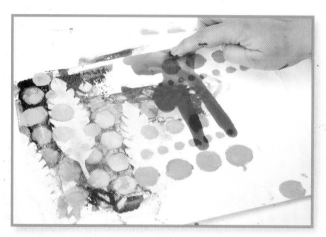

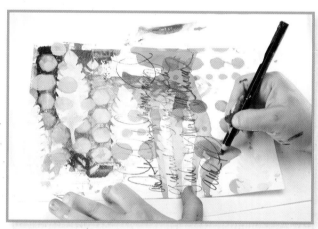

7 Puddle some orange ink spray on the page and let it run and drip. You can guide it with your fingers if you like.

8 Write along the drips with a pencil that will show up well on paint. I used the Lyra Color Giant.

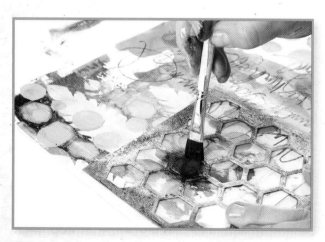

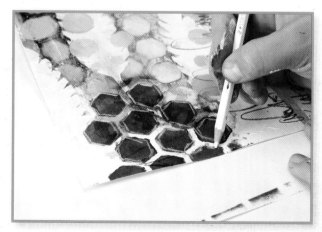

9 Choose another stencil and stencil through it with turquoise paint.

10 Use a white pencil to outline the turquoise stenciling and add random scribbly circles to the page.

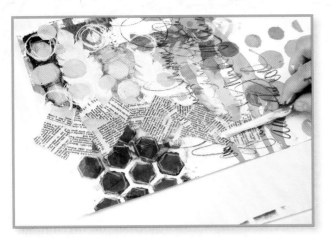

11 Tear up an old book page and use matte gel medium to glue it to the page in a river-like shape. A river of book paper is one of my secret weapons. It acts like a neutral and provides an anchor for a future focal point.

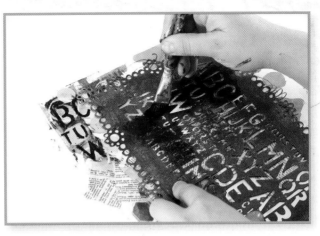

12 Choose a stencil and add some more stenciling with Payne's Grey paint.

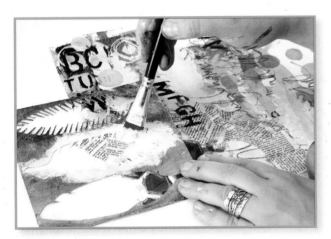

13 Go back to a stencil you've used previously and stencil it over all of the layers with white paint.

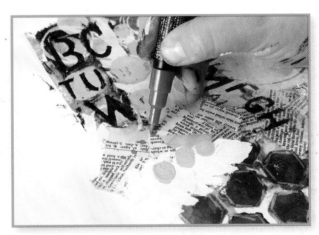

14 Add some yellow paint dots to the page in a few areas. Add some dots with a red paint pen. Because red is such a strong color, I put it near my focal point to help draw the eye.

Repetition Creates Unity

Repetition is helpful when you're layering. Limit yourself to three or four stencils and colors, repeating them as you go. The repetition creates unity within the piece and helps you control the piece as the layers build.

Visit CreateMixedMedia.com to sign up for the free newsletter!

75

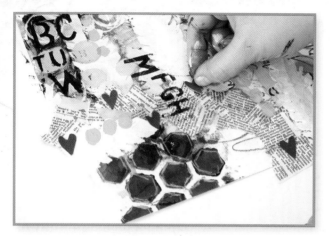

15 Paint a piece of sticky-back canvas blue, cut hearts from it and glue the hearts along the paper river.

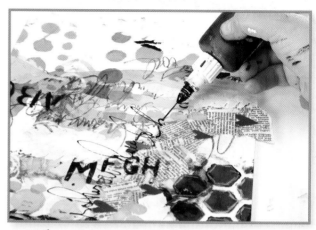

16 Write along the paper river with an applicator bottle filled with black fluid paint.

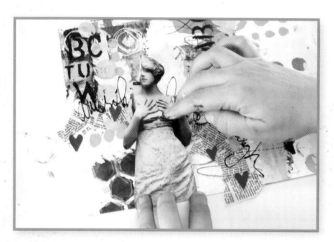

17 Glue on a vintage photograph for a focal point. I made sure my image touches the paper river. That helps anchor it to the page.

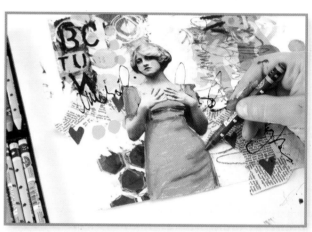

18 Color in any parts of the vintage image that you like with Neocolor II crayons. I gave my gal pink cheeks and an aqua dress.

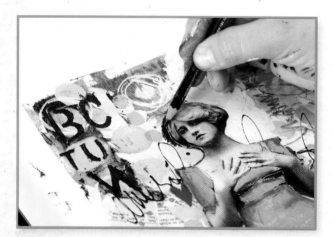

19 Outline the vintage image with the Stabilo All pencil.

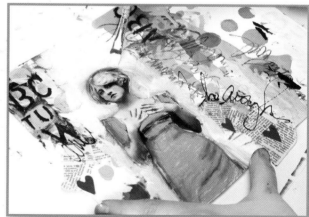

20 Paint around the image with Titanium White paint. Allow the paint to mix with the Stabilo All pencil. You'll get a gray color field around the image that will help it stand out from the background.

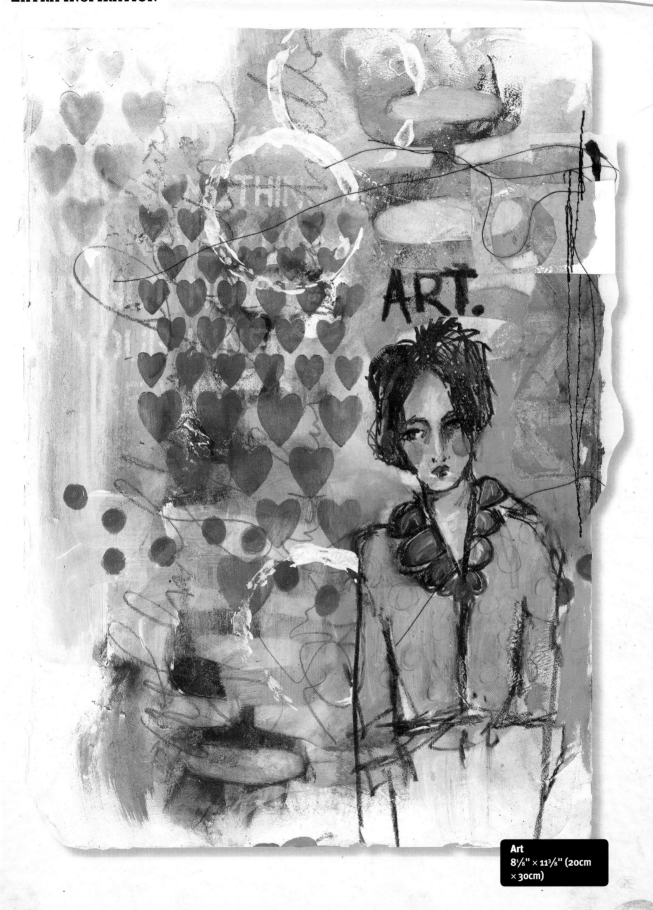

Art
8⅛" × 11⅜" (20cm × 30cm)

Visit CREATEMIXEDMEDIA.COM to sign up for the free newsletter!

77

Fixing Overwrought Layers by Isolating and Reducing

We've all made artwork where we took the layering a bit too far. I still occasionally overdo my layers, because sometimes once I get going it's hard to stop. Try this technique for salvaging an overwrought page (for more ideas on fixing overdone layers, see the "Power of Black and White" chapter of my first book, *Art Journal Freedom*).

MATERIALS

acrylic paint (white, blue, turquoise, dark blue)

needle bottle with white paint

paintbrushes

Stabilo All pencil

stencils

your journal

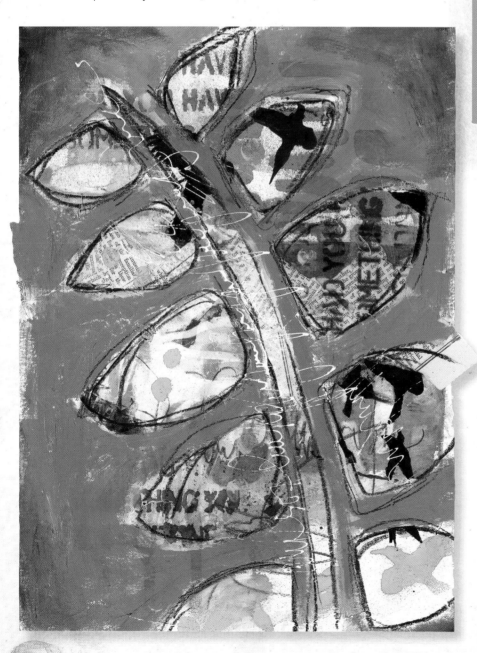

Visit CREATEMIXEDMEDIA.COM/ART-JOURNAL-COURAGE for bonus downloads and more!

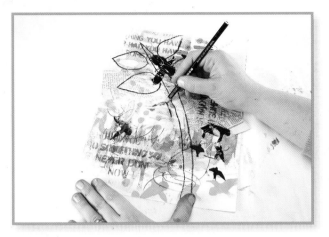

1 Choose a journal page you don't like or one that is over-done. Draw a stem and leaves onto the page with the Stabilo All pencil.

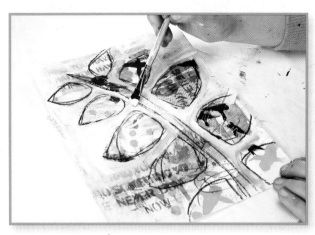

2 Paint around the drawing with white paint.

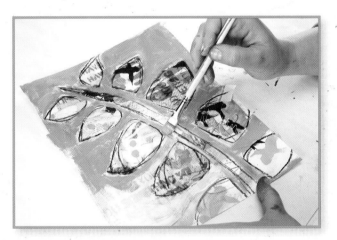

3 While the paint is wet, paint around it with turquoise paint.

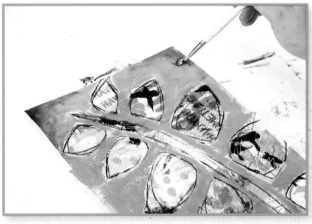

4 Add some dark blue paint to the edges of the page.

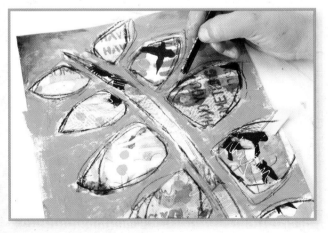

5 Take the Stabilo All pencil and redraw or reinforce any lines you may have accidentally painted over.

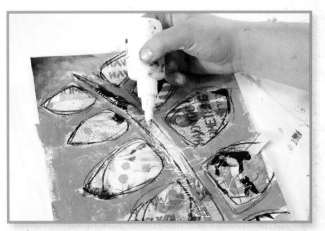

6 Write on the page with the white paint in the needle bottle.

Visit **CreateMixedMedia.com** to sign up for the free newsletter!

79

6

Courage to Try New Techniques

Fear: You don't have the newest, trendiest art supplies so you can't make good art.

Courage: You can use supplies in unexpected ways to keep your artwork fresh and exciting!

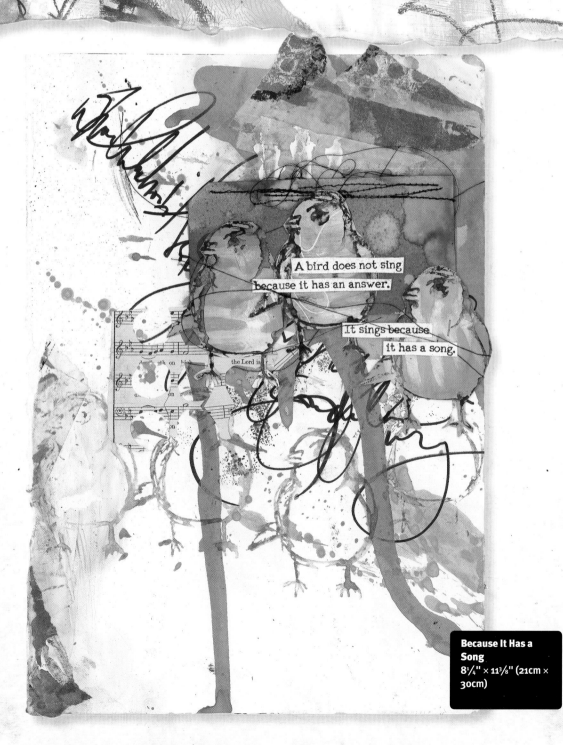

A bird does not sing because it has an answer.

It sings because it has a song.

Because It Has a Song
8¼" × 11³⁄₈" (21cm × 30cm)

Sometimes what paralyzes us artistically is the insecurity that we're not artists, that we don't know enough to make good art, that we don't have the latest and greatest art supplies. I love new art supplies, like everyone else, but both budget and storage issues prevent me from having all of the new, trendy items.

In this chapter, you'll take a look around your studio and pull out your favorite art supplies like stamps and stencils, and basics like sheet protectors and fun foam. You can use these materials in interesting ways to make great layers for your art. Try pulling out a stamp or stencil and using it every way you can think of. Use it in your foundation, middle and top layers. Use it with five different types of media. Really push yourself to experiment and play.

In addition, I'll show you my favorite nontraditional ways to use rubber stamps and stencils. And I'll show you a few ways to incorporate printmaking onto your pages.

I'm obsessed with printmaking. Why do I go to the effort to add prints to my work instead of simply adding paint with a brush? Because prints have a different look and feel than direct-to-paper paint does. They have a unique visual quality that you simply cannot replicate with a brush.

I will show you a few of my favorite monoprinting and collagraph techniques. Monoprinting is a type of printing from which you pull only one print from each process. No two monoprints are alike, since you have to create a new plate (i.e., printmaking surface) each time you make a print. Monoprints are spontaneous and unpredictable, which is probably why they appeal to me so much. Collagraph printing is when you make a collage of anything you can glue down, and then make a print from it.

One of the great things about monoprinting and collagraph printing is that you can use what you already have in your studio—papers, plastics and your acrylic paints. Easy!

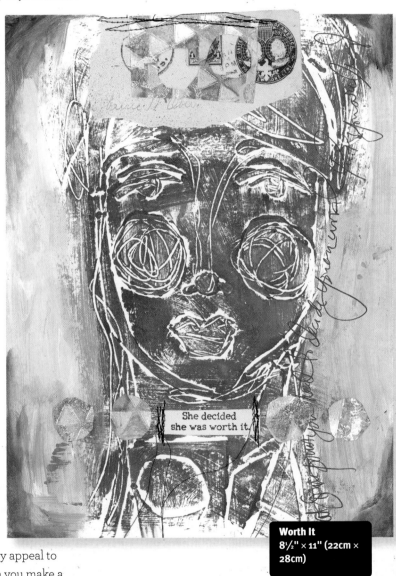

She decided she was worth it.

Worth It
8½" × 11" (22cm × 28cm)

Visit CREATEMIXEDMEDIA.COM to sign up for the free newsletter!

81

Stamping Without an Ink Pad— Neocolor II Crayons

Stamps and ink pads go hand in hand, but what if you ditched the ink pad and stamped with other media instead? I love to load my stamp up with paint, bleach, crayons, pastels, ink sprays, you name it. You don't get a perfect stamped image when you use other media, but you do get an interesting image upon which to build layers. This method uses water-soluble crayons, like Neocolor IIs or Gelatos.

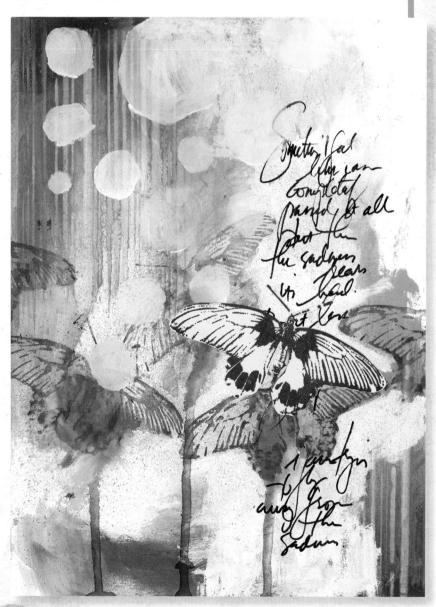

MATERIALS

acrylic paint (Light Blue Permanent, Phthalo Blue, white)

baby wipes

black Archival ink

black pen for journaling

cardstock or tag

gesso

gel medium

ink sprays in Fresh Lime and Funky Fuschia

Neocolor II crayons

paintbrushes

rubber stamp

scissors

stencils

water mister

your journal

Visit CREATEMIXEDMEDIA.COM/ART-JOURNAL-COURAGE for bonus downloads and more!

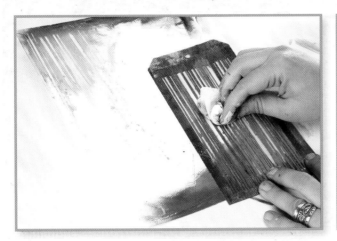

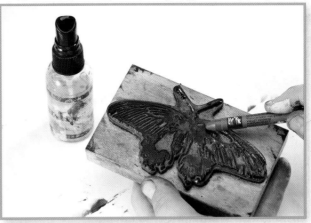

1 Gesso a page in your journal and let it dry.
Paint some Light Blue Permanent acrylic paint in the top left and bottom right corners of the page. Add some Phthalo Blue paint to the corners.
Place a stencil over the paint and rub through it with a baby wipe. Repeat at the bottom of the page.

2 Mist your stamp with water.
Color on your stamp with one or more Neocolor II crayons. If necessary, mist the stamp again to keep it damp.

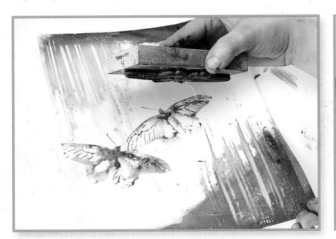

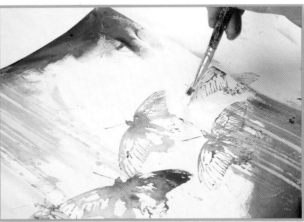

3 Stamp the image onto your page.
Mist the stamp with water and stamp again. Apply more color, if necessary. I stamped five times on my page.

4 Paint around a few of the stamped images on the page with white paint.

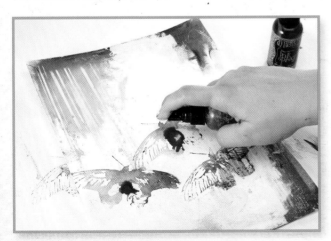

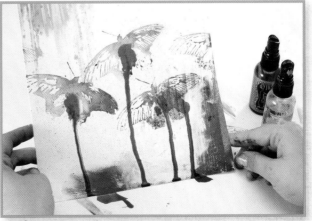

5 Add some sprays of Funky Fuschia ink to the center of your stamped image.

6 Spritz the ink with water and lift the page so the ink runs.

Visit CREATEMIXEDMEDIA.COM to sign up for the free newsletter!

83

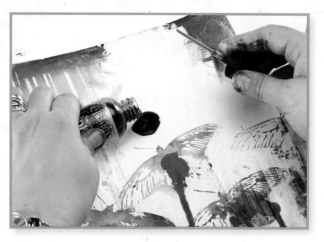

7 Pour some Fresh Lime ink spray to the top of the page.

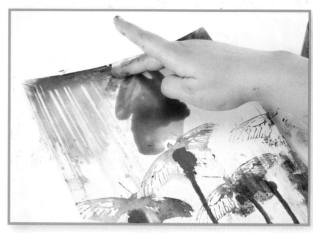

8 Spritz the ink with water and guide it using your fingers.

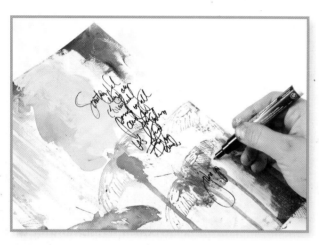

9 Add journaling to the page.

Know Your Colors

Keep the green ink away from the fuchsia ink so they don't mix and become muddy.

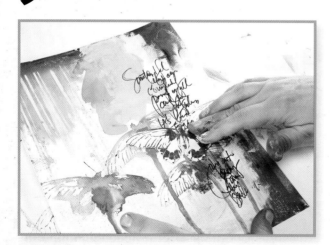

10 Ink your stamp with black ink and stamp it onto a tag or cardstock. Cut it out.
Glue your cut-out stamped image onto the page using a gel medium.

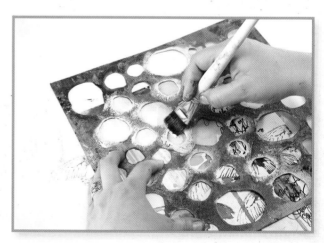

11 Use white paint and a stencil to add a layer of white stenciling to the top of the page.

Visit CreateMixedMedia.com/art-journal-courage for bonus downloads and more!

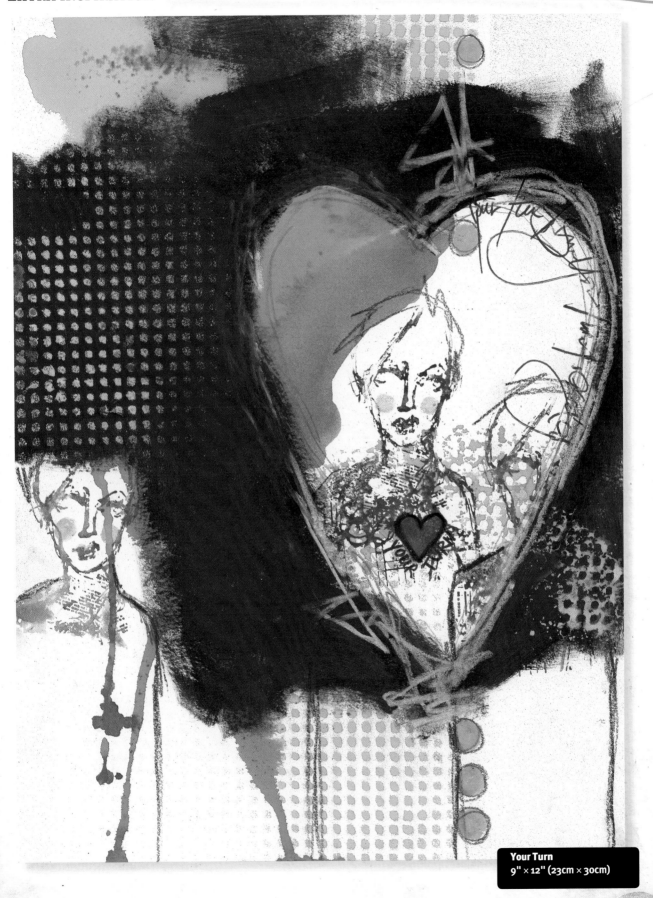

Your Turn
9" × 12" (23cm × 30cm)

Visit CREATEMIXEDMEDIA.COM to sign up for the free newsletter!

85

Stamping Without an Ink-Pad—PanPastels

This technique typically uses an ink pad, but for this project it's a clear Watermark pad and not your standard ink. The color comes from PanPastels. I love to do this technique in my foundation layer. By starting with stamped images, I can create a page that has powerful repetition and meaning.

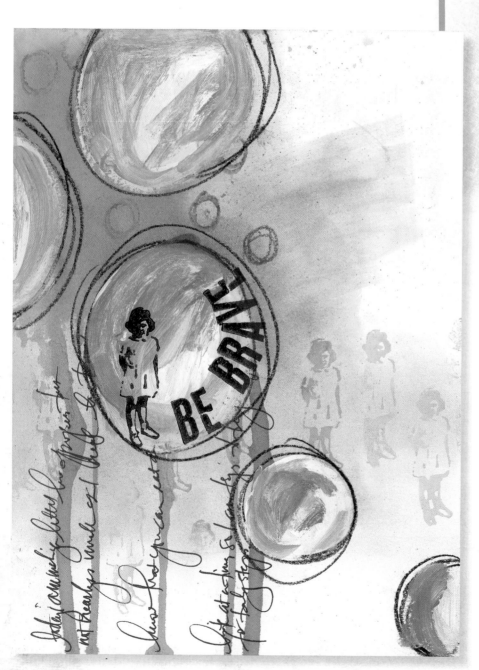

MATERIALS

acrylic paint (white, turquoise)

alphabet stamps

Archival black ink pad

black pen

ink sprays in Bubblegum Pink, White Linen and Pure Sunshine

Neocolor II crayons

paintbrushes

PanPastels

sponge

Stabilo All pencil

stamps

water spray bottle

Watermark ink pad

your journal

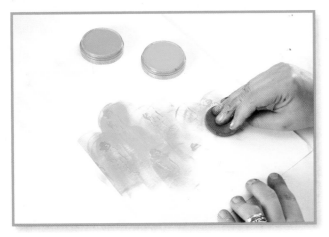

1 Stamp several images on your page with Watermark ink. Gently use a sponge to rub PanPastel color over the stamped images. The ink will grab the pastel and the image appears.

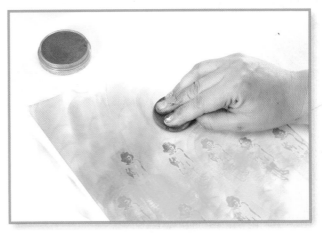

2 Use another color of PanPastel at the top of the page.

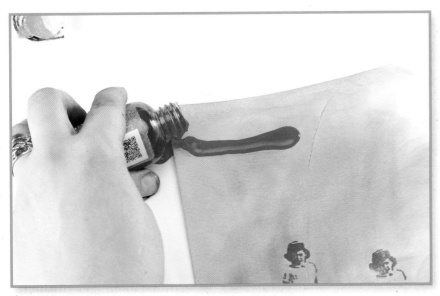

3 Spill some Bubblegum Pink ink on the top of the page.

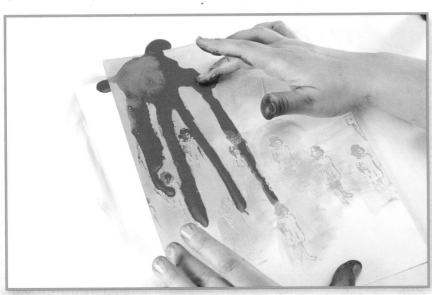

4 Add water to the spill and lift your journal so the ink runs. Use your fingers to guide the drips as they start running.

Visit CREATEMIXEDMEDIA.COM to sign up for the free newsletter!

87

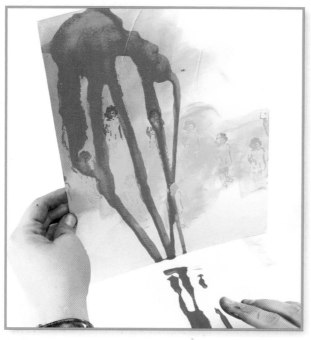

5 Allow the drips to run off the page.

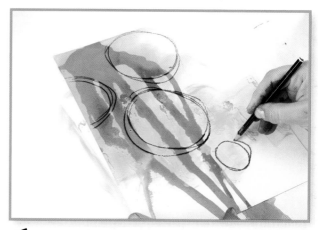

6 Use the Stabilo All pencil to draw five scribbly circles on the page.

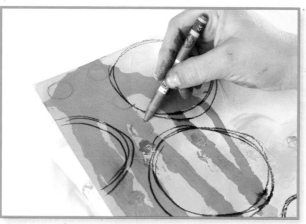

7 Use a Neocolor II crayon to add some circles to the pink area. You can do this while the ink is still wet.

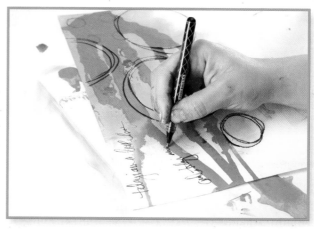

8 Write your journaling along the drip lines on the page.

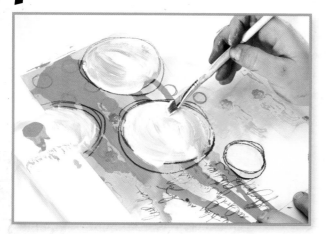

9 Paint the inside of the circles with white paint, and then paint them with a little bit of turquoise paint.

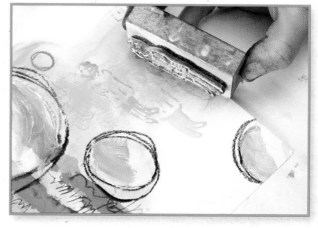

10 Spray your stamp with White Linen spray ink, then with Pure Sunshine spray ink.
Stamp a few more images in the background of your page.

Visit CREATEMIXEDMEDIA.COM/ART-JOURNAL-COURAGE for bonus downloads and more!

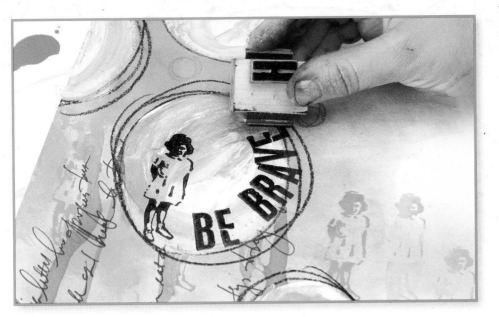

11 Use alphabet stamps and Archival black ink to add words to your biggest circle.

Repeat your stamped image by stamping it in the circle with your stamped text.

EXTRA INSPIRATION

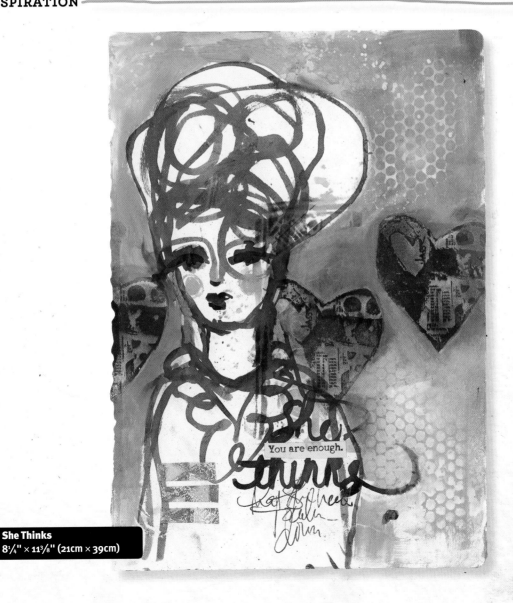

You are enough.

She Thinks
8¼" × 11⅜" (21cm × 39cm)

Visit **CREATEMIXEDMEDIA.COM** to sign up for the free newsletter!

89

Layered Stencils

If you're like me, you have a drawer full of wonderful stencils. Try combining them and overlapping them to create different patterns and styles.

MATERIALS

acrylic paint (yellow, teal)

baby wipes

black pen for journaling

gesso

glue

ink sprays in pink and orange

Neocolor II crayons

old book page

old gift card

scissors

Stabilo All Pencil

stencils

vintage images

your journal

Visit CREATEMIXEDMEDIA.COM/ART-JOURNAL-COURAGE for bonus downloads and more!

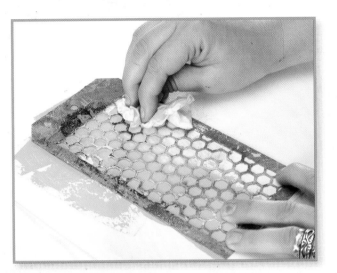

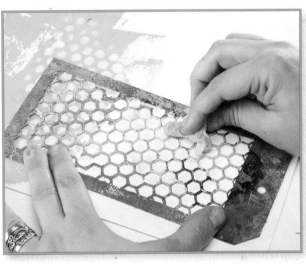

1 Gesso a page in your journal and let it dry.
Scrape yellow paint onto the page using an old gift card. Lay a stencil down on the paint and rub through it with a baby wipe.

2 Take the dirty baby wipe and rub through the stencil on a few other areas of the page to extend the stencil design.

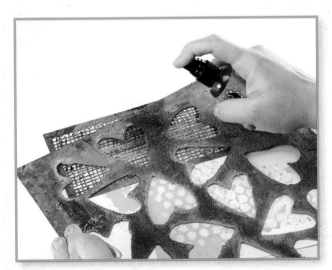

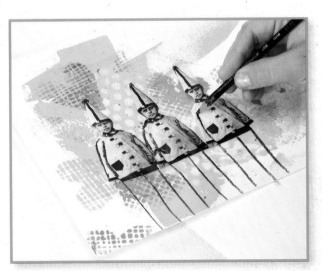

3 Lay a detailed stencil down on your page, and then lay a larger stencil over it. Spray through them with pink and orange ink sprays.
Move the stencils around and spray several areas of the page.

4 Glue down some vintage images for your focal points Use the Stabilo All pencil to outline the images and add fun details like the pockets and buttons I added here.

Visit **CREATEMIXEDMEDIA.**COM to sign up for the free newsletter!

91

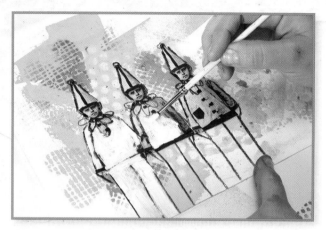

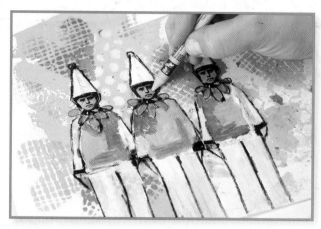

5 Paint some of the clothes with acrylic paint.

6 Add any color you'd like to the images with Neocolor II crayons.

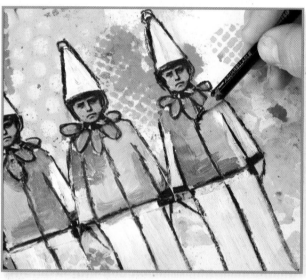

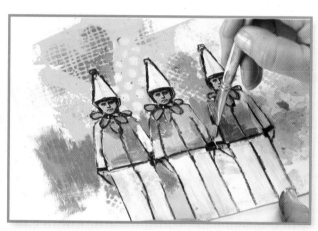

7 Use a Stabilo All pencil to redraw some of the lines that were covered up with the paint and Neocolor II crayons.

8 Use teal paint to paint away some of the background around the images. If my background is too strong, I always paint some of it away. Doing so brings your focal point forward.

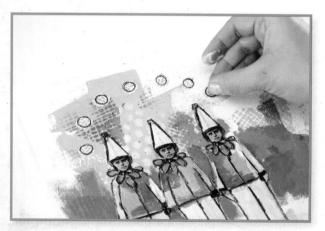

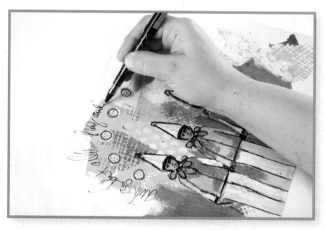

9 Cut small circles from book paper and glue them to the page in a circle over the figures' heads.

10 Journal over the book paper circles, and add journaling on the figures.

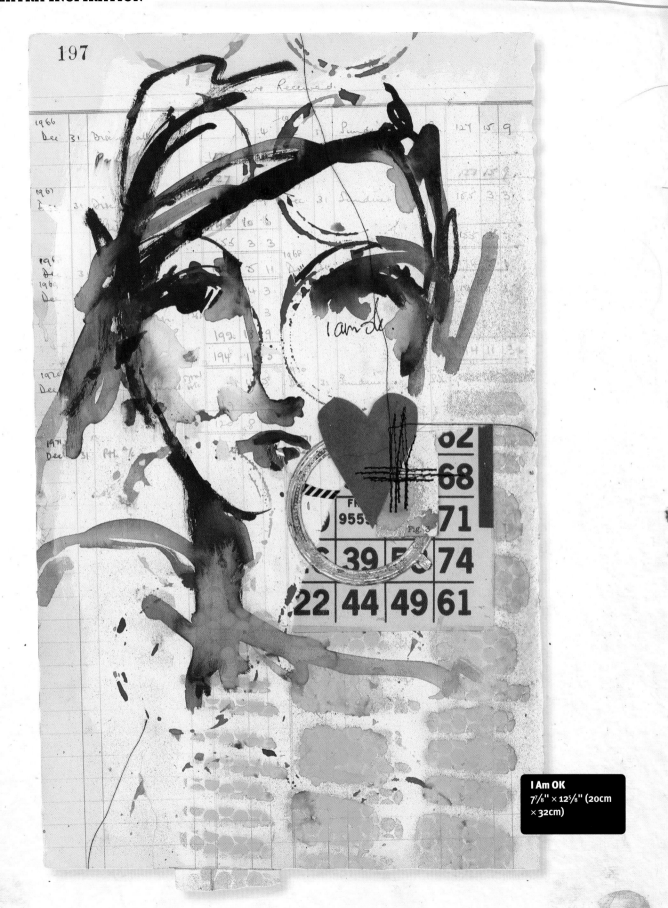

I Am OK
7⅞" × 12⅝" (20cm × 32cm)

Visit CREATEMIXEDMEDIA.COM to sign up for the free newsletter!

93

Incorporating Printmaking—Plastic Monoprints

A simple piece of plastic (like a sheet protector) is all you need to add interesting prints to your artwork. I used to do a lot of monoprinting with index cards, but I find that plastic gives me a more interesting print (since it doesn't absorb any of the medium). I don't wash my sheet protectors. I let the paint build up on them, and when they look interesting, I cut them up and collage them into my artwork.

MATERIALS

- acrylic paint (pink, white)
- baby wipes
- black pen
- gel medium
- gesso
- Neocolor II crayons
- PanPastels
- paintbrushes
- Ranger Watermark ink pad
- rubber stamp
- sheet protector
- Stabilo All pencil, black
- stencil
- vintage image
- your journal

Visit CREATEMIXEDMEDIA.COM/ART-JOURNAL-COURAGE for bonus downloads and more!

1 Gesso a page in your journal and let it dry. Stamp an image on the page with Watermark ink.

2 Gently brush PanPastel over the stamped image.

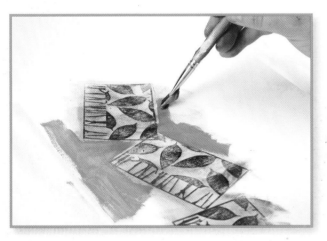

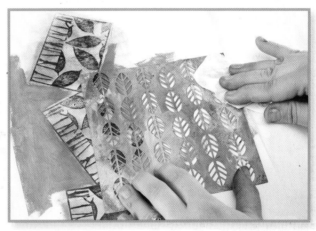

3 Paint around the stamped images with pink paint.

4 While the paint is still wet, lay down a stencil and rub through it with a baby wipe to remove some of the paint.

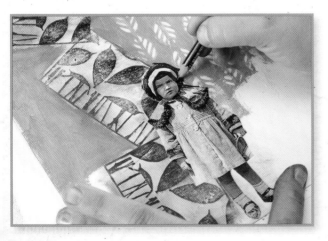

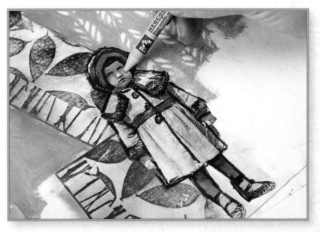

5 Glue a vintage image on the page using gel medium. Outline the image with a black Stabilo All pencil.

6 Use Neocolor II crayons to add color to the image and to any other areas of the page.

Visit **CREATEMIXEDMEDIA.COM** to sign up for the free newsletter!

95

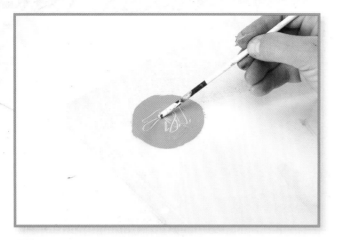

7 Use your finger or a brush to paint three circles onto a sheet protector. Use the end of your paintbrush to draw into the paint circles.

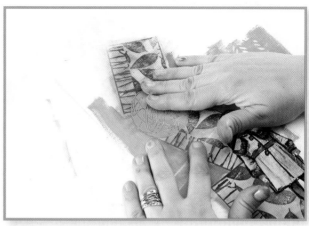

8 Print the circles onto your page by gently laying down the page protector, paint side down. Burnish very gently.

It Takes Practice

Expect a learning curve when it comes to how much paint to put on the sheet protector. If you put too much, you just get squished paint. If you don't put enough, it won't print. Play around and practice on some scratch paper before you print on your page.

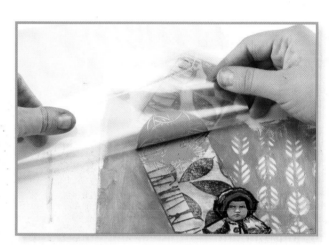

9 Repeat the printing on the page wherever you like.

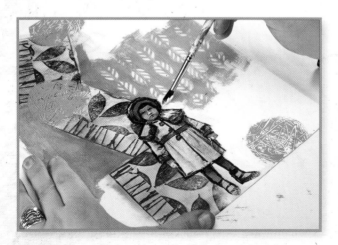

10 Paint around one side of the vintage photo using white paint.

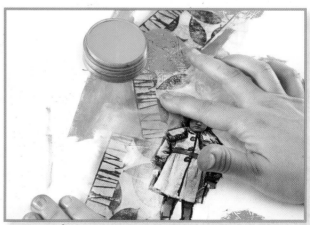

11 Lightly spread PanPastel around the other side of the image using your fingers.

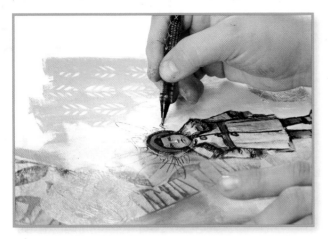

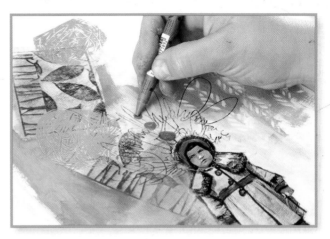

12 Use a black pen to add journaling that circles around the head of the image.

13 Use a Neocolor II crayon to draw three circles above the figure's head.

EXTRA INSPIRATION

Coming to Terms
10⅛" × 15" (25cm × 38cm)

Visit CREATEMIXEDMEDIA.COM to sign up for the free newsletter!

97

Incorporating Printmaking— Fun Foam Prints and Collagraph Prints

The word *collagraph* comes from collage. To make a collagraph print, we first need to make a collagraph plate. That sounds fancy, but it's simply a piece of paper or cardstock with items glued on it. I cut a shape out of cardstock (for example, a circle), and then I glue things like punched shapes, string, grass, sequin waste, anything that will create texture, onto it. Then you load your plate up with paint, lay down a piece of paper and burnish it to make a print. For this technique, you will load up your collagraph plate with paint and then press the plate right onto your journal page to make a print.

MATERIALS

- acrylic paint
- Archival ink pad in black
- ballpoint
- black pen for journaling
- brayer
- cardstock
- gesso
- glue
- ink sprays
- old book page
- paintbrush
- paper punches
- piece of fun foam
- scissors
- stencils
- water spray bottle
- your journal

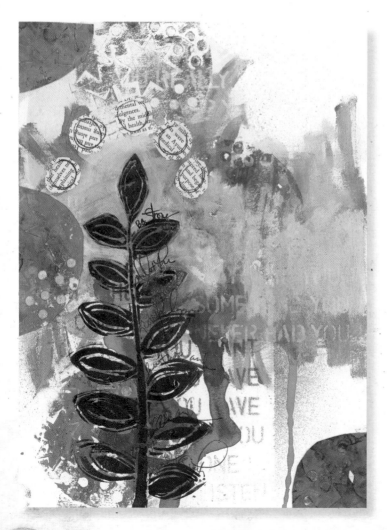

If you've used materials like paper and cardstock on your plate, eventually your paint medium will soak into the plate and make it hard to print from (the plate will start to fall apart). I find I can get two or three good prints from a paper collagraph. Then I set it aside and let the paint on it dry. After it's dry, I can keep printing from the plate or I can cut up the plate and use it in my work.

Fun foam prints are just plain fun. For this technique, you create a printing plate by drawing or impressing a design into the foam. Then you load the foam with medium and print with it.

Visit CreateMixedMedia.com/art-journal-courage for bonus downloads and more!

1 Gesso a page in your journal and let it dry. Use your brush to apply a couple of paint colors to the page. Make your brushstrokes large and expressive!

2 Use several stencils and ink spray colors to make an inky background.

3 Add some spritzes of water to make the ink run and drip.

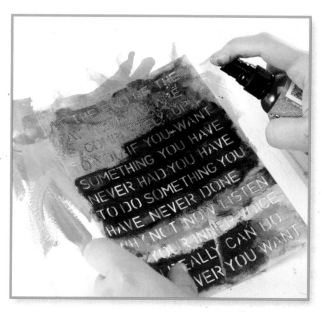

4 Spray some ink through a stencil on the page. I used the same color that I dripped with.

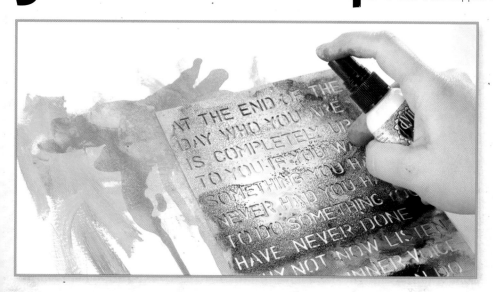

5 Switch inks and move the stencil before spraying again.

Visit CREATEMIXEDMEDIA.COM to sign up for the free newsletter!

99

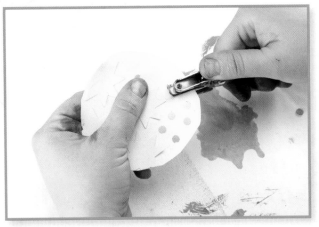

6 Cut a shape out of cardstock; for instance, a circle or a heart. Use a few paper punches to punch some shapes from the excess cardstock and glue them onto your cut-out shape. This shape is called a "collagraph plate."

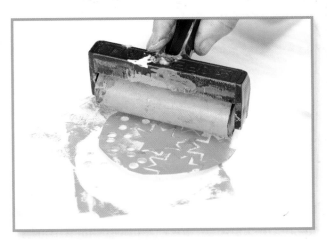

7 Load your brayer with acrylic paint and apply the paint to the collagraph plate.

8 Pick up the plate and print it, face down, onto your page. Repeat the printing two more times. (Load the plate with paint each time.)

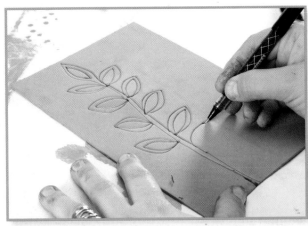

9 Use a ballpoint to press a design or pattern into a piece of fun foam. Press hard—you need to emboss the design deep into the foam. Try tracing a stencil shape into the foam. You can turn every stencil you own into a print.

10 Ink the shape with Archival black ink and press it onto your page. I like to use the top of the ink pad to press the foam onto my page and to ensure an even print.

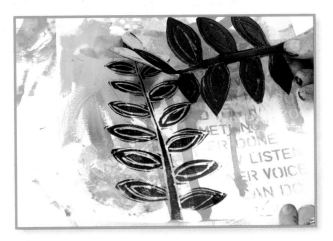

11 Peel the foam up to reveal the print.

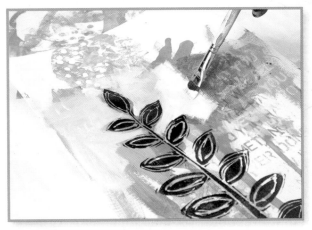

12 Paint around the print with white paint, or use white ink spray.

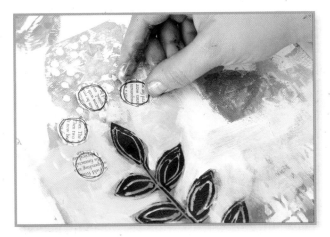

13 Add text paper circles to the page. I like to outline my circles with a black pen so they stand out.

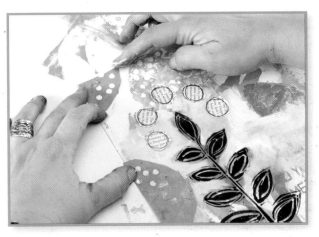

14 If you're finished with your collograph plate, cut it into pieces and adhere the pieces, color side up, to your journal page.

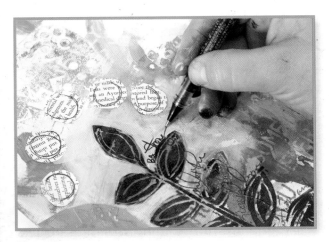

15 Write journaling on your page.

Visit CREATEMIXEDMEDIA.COM to sign up for the free newsletter!

101

Courage to Not Plan

Fear: I have to have everything planned in my head before I work.
Courage: By working organically and intuitively, you can create interesting art and push yourself to see more.

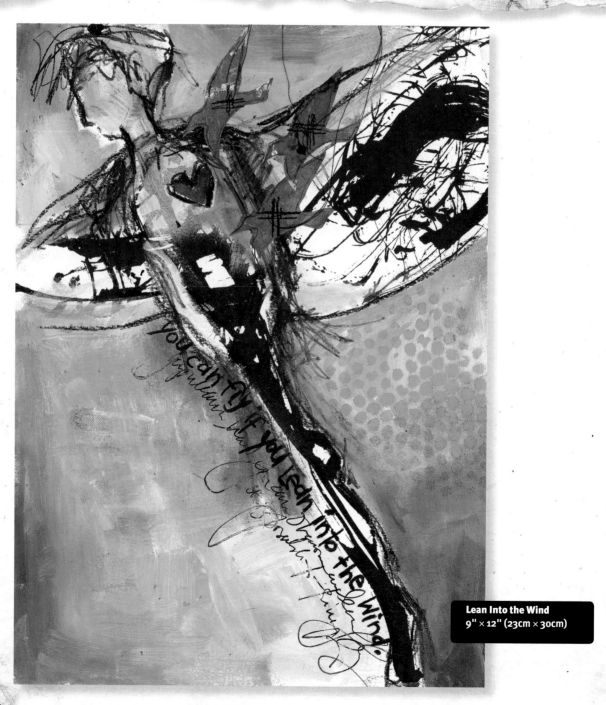

Lean Into the Wind
9" × 12" (23cm × 30cm)

Visit CREATEMIXEDMEDIA.COM/ART-JOURNAL-COURAGE for bonus downloads and more!

I always say that when I start a page, I have no concept or idea in my head about what the finished page will be.

And that freaks people out. Big time.

If you're a planner and a perfectionist, an organic, "let's just see what happens" working style may be hard for you. But I want you to try it because the process is artistically valuable. Working organically and intuitively will help you to:

• Grow as an artist.
• Listen to your inner voice.
• Evaluate what is in front of you and make better decisions about where to go next.
• Embrace accidents and imperfections.
• Take a leap of faith.

To create organically, first you will make marks on your page. Then you'll read and evaluate the marks. You'll "listen" to them, and they'll tell you what to do next.

Visit CREATEMIXEDMEDIA.COM to sign up for the free newsletter!

103

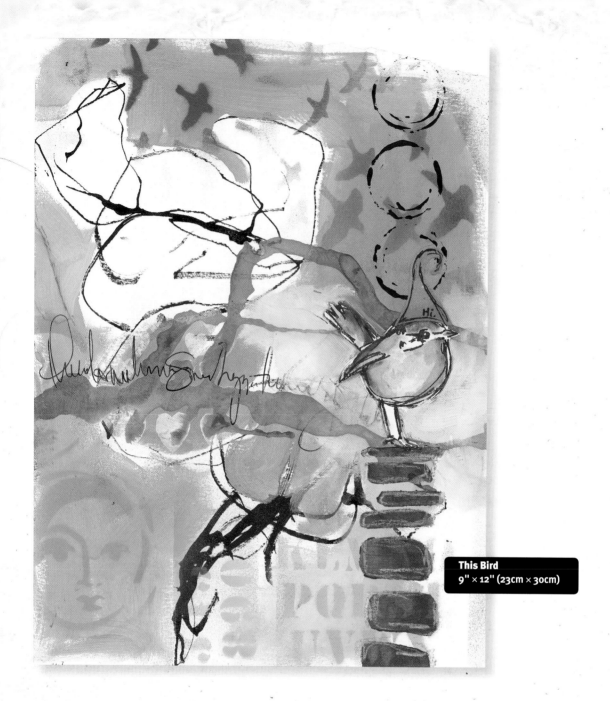

This Bird
9" × 12" (23cm × 30cm)

If you go through this process but you don't see any identifiable shapes or forms in your marks, just keep painting. Sometimes you see something later on. Sometimes you end up seeing nothing, but you've created an interesting background!

I have learned that if you're having a hard time seeing, you can get better with practice. I teach this method in class and after we make our marks, we all gather together to look at each other's work. It can be very helpful to have another pair of eyes look at your marks and help you evaluate them. Sometimes a fellow student will help you see something in a mark that you can't.

Occasionally I have someone in class who simply cannot see. She struggles to see anything in her own

piece as well as in the pieces of her classmates. And to be fair, I don't see something in every single mark I make. Sometimes I see a bird flying or a woman holding a baby, but sometimes I just see scribbles. I know it's frustrating to not see what someone else can see, but I look at mark making as an opportunity to practice. If you struggle to see anything in your scribbles, I want you to try making marks every single day and practice your observation skills. As you practice, your skill will improve and you will start seeing more. You have to exercise the muscle for it to get stronger. You have to challenge your brain to look for the unobvious images. Also try finding shapes in the clouds and patterns in the concrete. Practice, and your "seeing" skills will improve.

Making Unplanned Art

Remember, don't be hard on yourself. They'll make more paper. Art takes effort and practice. So relax, open your mind and get ready to experiment. At best, you'll end up with an interesting painting. At worst, you'll end up with an interesting background. And really, that's not bad at all.

MATERIALS

acrylic paint

book paper and other papers for collage

cotton rag

matte gel medium

gesso

markers in black and white

paintbrushes

Stabilo All pencil

stencil

water

your journal

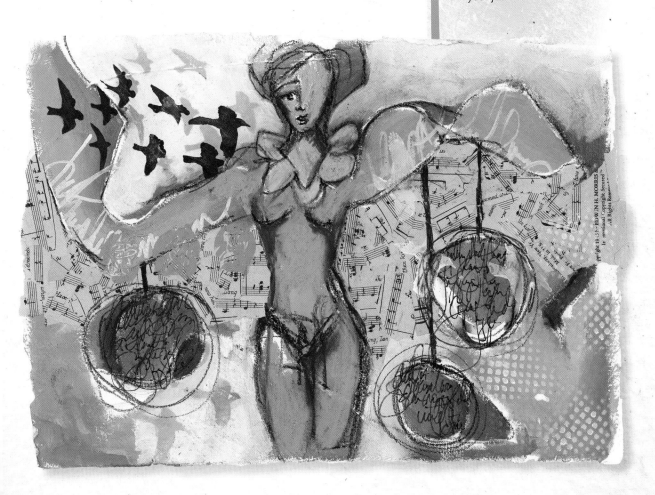

Visit CREATEMIXEDMEDIA.COM to sign up for the free newsletter!

105

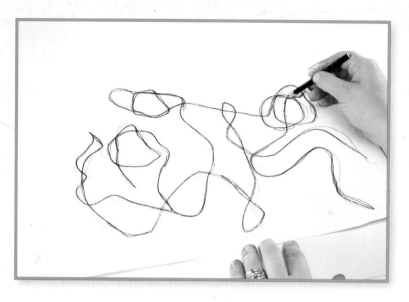

1 Gesso a page in your journal and let it dry. Take the Stabilo All pencil and scribble all over your page. I like to make large shapes and not just random swirls. Try circles and rectangles connected with lines. Try scribbling some clouds.

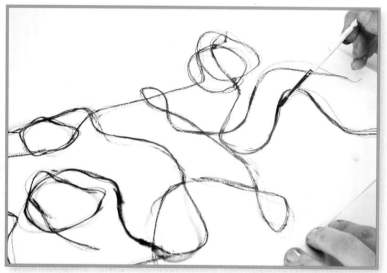

2 Wet a brush and run it over your scribble marks to partially dissolve them. I like to dissolve some of the marks slightly but leave some of them undissolved. If you add too much water, your lines turn into watery paint and that's not what you want.

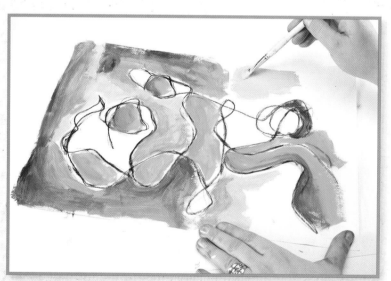

3 Paint your scribbled page. I like to start with a light color, and then use a darker shade of the same color around the edge of the area. This shades the area and gives it more visual dimension. Use colors you like and just have fun. Continue coloring until you've colored in all the spaces on your page.

You don't have to cover every square inch of background with paint. Leave some areas open so the layers underneath peek through. This is how you layer: You do one layer, then partially cover it with another layer.

Practice Seeing

It takes practice to see. You can get better at it. You can do it.

4 Look at your page from all angles. Do you spot anything in the scribbles?

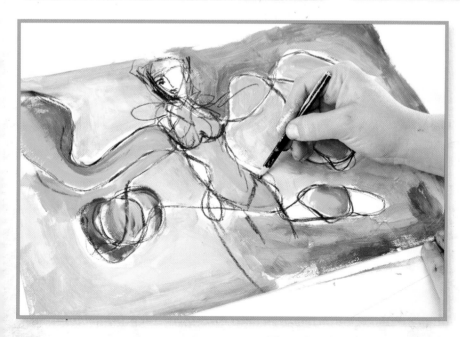

5 Use the Stabilo All pencil to isolate and reinforce any images that you see on your page. I saw a woman with outstreched arms in my piece, so I used the pencil to make her outline stronger and to bring her image forward.

Visit CreateMixedMedia.com to sign up for the free newsletter!

107

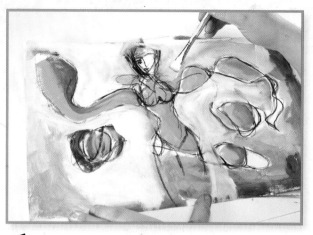

6 Paint around the shapes or figures you isolated with acrylic paint. I used white and gray paint. The idea is to remove some of the background from around the figures to make them stand out.

7 While your paint is still a bit wet, lay a stencil down over your background. Wet a cotton rag and rub through the stencil to remove some of the paint.

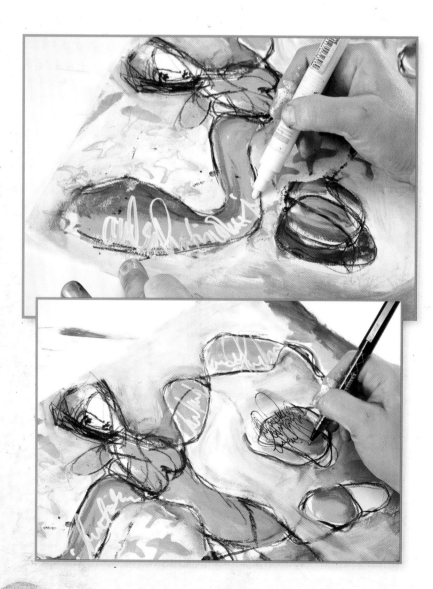

8 Write on your page. I like to write with both a black marker and a white marker. Write on your isolated images, around them, wherever you like!

Visit CreateMixedMedia.com/art-journal-courage for bonus downloads and more!

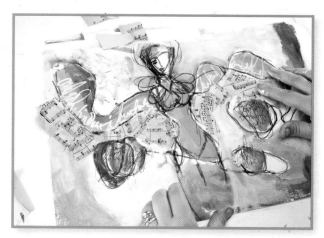

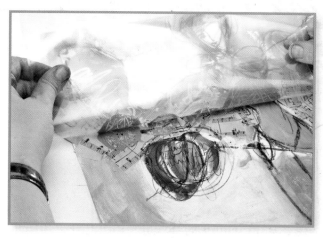

9 Add some collage papers to your page. I like to tear up a sheet of book paper. Then I use matte gel medium to add the pieces to my composition. The pieces can go in the background or on your shapes/figures.

10 Print on your page with the techniques in chapter six. I used monoprinting.

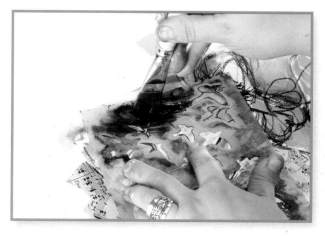

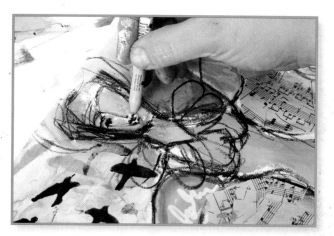

11 Use a dry brush to swirl some acrylic paint through a stencil. Be careful to use only a small amount of paint on your brush to prevent seepage under the stencil.

12 Use the Stabilo All pencil to add details to the images that you isolated from your scribbles. Do anything that you need to do to help your images shine and to help them stand out from the background.

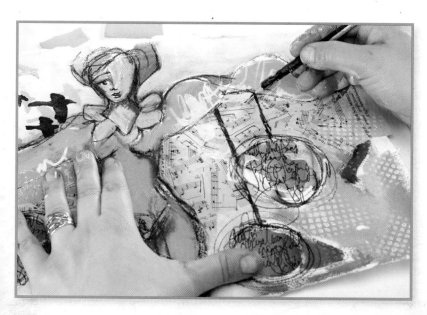

13 Take a long look at your piece. Are you done? Do you need more writing? More stenciling? More monoprinting? Trust your gut and do it!

Visit CreateMixedMedia.com to sign up for the free newsletter!

109

Courage to Step Out of the Journa

Fear: Working in my journal is comfortable, but I'm afraid to move on to other projects.

Courage: Moving your art from the journal page to other substrates and mixed-media projects is satisfying and exciting!

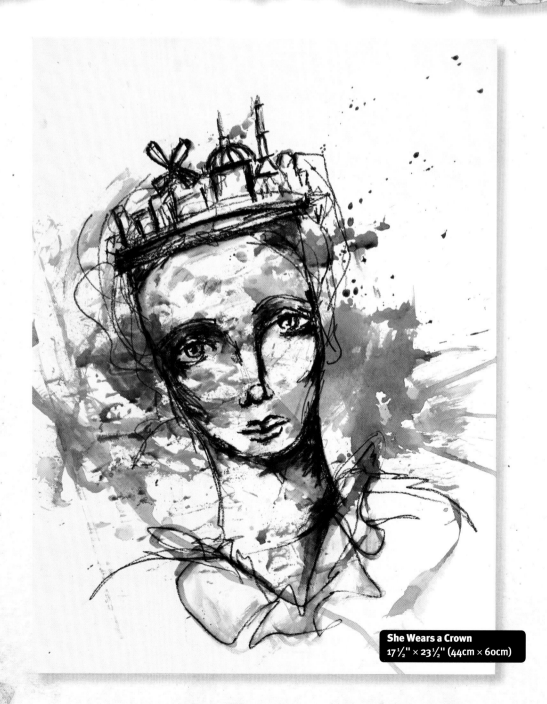

She Wears a Crown
17 ½" × 23 ½" (44cm × 60cm)

Visit CREATEMIXEDMEDIA.COM/ART-JOURNAL-COURAGE for bonus downloads and more!

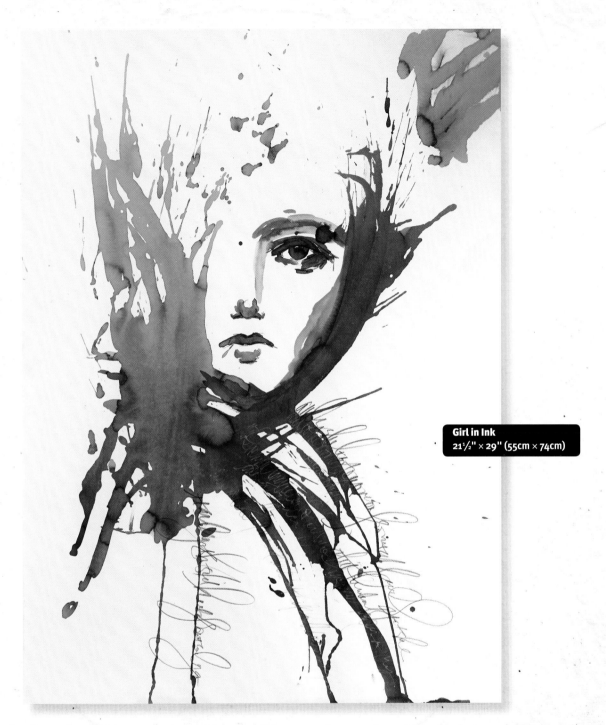

Girl in Ink
21½" × 29" (55cm × 74cm)

I know that I'm guilty of relying on my journal for most of my artistic outlet. There's something so safe and comfortable about a journal. When I do a page I don't like, I just laugh and turn the page for a fresh start. I can play and experiment and not really worry about who will see it.

It's important that we step out of our journals now and then, and stretch our artistic skills by using other substrates. Try working on stretched and unstretched canvas, wood panels, pieces of cardboard, large sheets of watercolor paper, anything goes! The great thing about stepping out of your journal is that you already know how to do it. You do. Because anything you do in your journal you can do on other substrates. It's fun and challenging to work on a piece larger than your typical journal page. Try it and see how much you grow as an artist!

I recommend paging through your journal and picking out your favorite pages. Use those pages as inspiration for your other mixed-media works. You can re-create the page exactly or use it as a jumping-off point to create something new.

Visit CREATEMIXEDMEDIA.COM to sign up for the free newsletter!

111

Painting a Wood Panel

I find it easier to paint on wood than on stretched canvas, because canvas has a "give" that I find hard to work with when I am drawing or doing reduction stenciling. You can buy premade cradled wood panels, which provide a lovely work surface. Or you can cut your own sheets of plywood or MDF (medium density fiberboard).

MATERIALS

12" × 12" (30cm × 30cm) wood panel

acrylic paint (green, turquoise, Payne's Grey, white, blue, pink)

baby wipes

ballpoint

black Archival ink pad

carbon paper

fun foam

gel medium

gesso

image to trace

Lyra Color Giant pencil

Neocolor II crayons

old book page

piece of sticky-back canvas

scissors

Stabilo All pencil

stencils

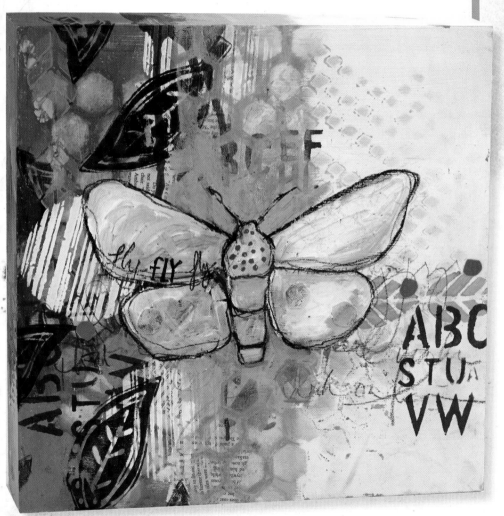

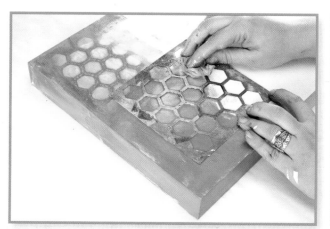

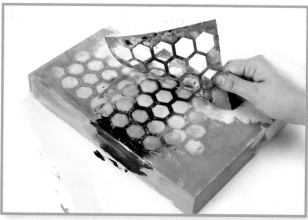

1 Gesso the entire panel and let it dry.
Paint green and turquoise paint on the left side of the board. Lay a stencil down over the paint and rub through it with a baby wipe or damp cotton cloth.

2 Paint Payne's Grey on the board, lay a stencil over it and rub through it with the wipe or cloth.

Use a Damp Cloth

If the baby wipe doesn't work because of the texture of the wood, try using a damp cotton cloth.

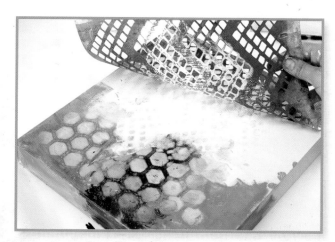

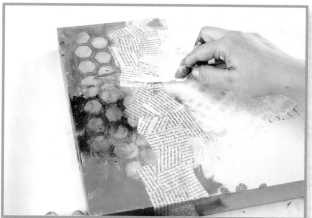

3 Paint white paint on the board, lay a stencil over it and rub through it with the cloth or wipe.

4 Tear up a book page and glue the torn pieces on your board. Make sure there's gel medium both under and over your book paper pieces.

Visit CreateMixedMedia.com to sign up for the free newsletter!

113

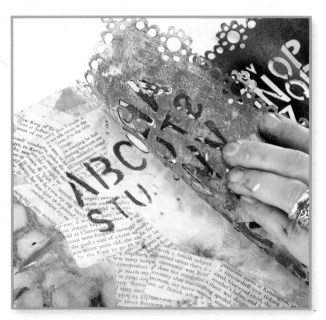

5 Use blue paint to paint through a stencil.

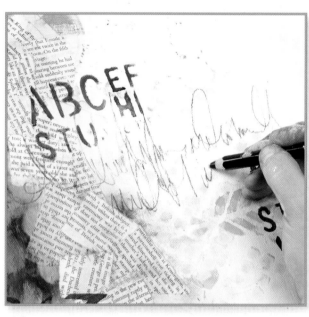

6 Use green paint to paint through a stencil on various areas of the board. Use a Color Giant pencil to write some journaling on the board.

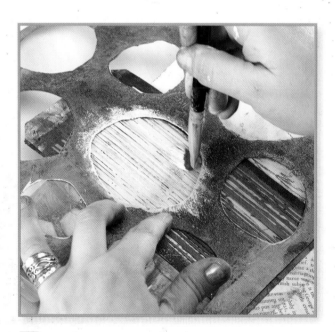

7 Lay a stencil with a fine pattern on the board, then lay a larger stencil over it. Paint through the layered stencils with white paint in various areas of the board.

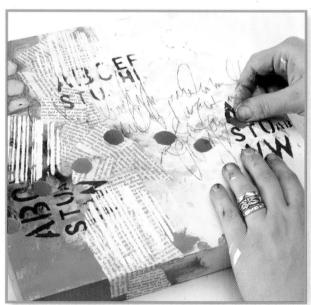

8 Cut small circles from a piece of pink-dyed sticky-back canvas and stick them on the board.

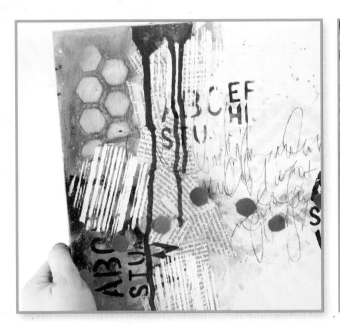

9 Water down some pink paint and drip it from the top of the board.

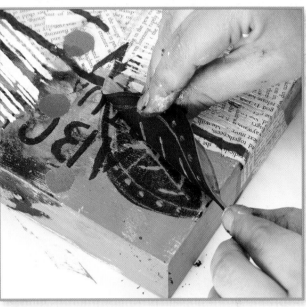

10 Make a foam printing plate with fun foam (see chapter six) and use black Archival ink to print it on several areas of the board.

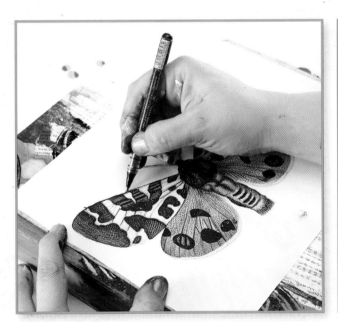

11 Trace an image onto your board with carbon paper and a ballpoint.

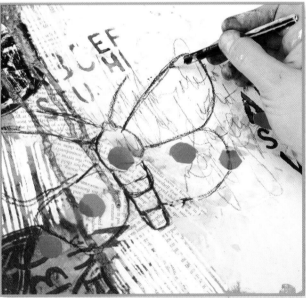

12 Go over the traced image with the Stabilo All pencil.

Visit **CreateMixedMedia.com** to sign up for the free newsletter!

115

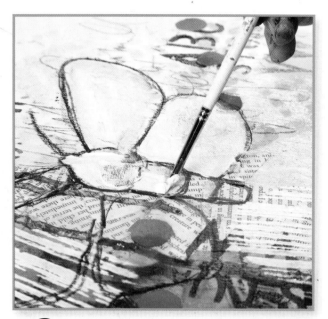

13 Fill in the image with white paint. Use the Stabilo All pencil to reinforce the lines of the image and to add some scribbly lines.

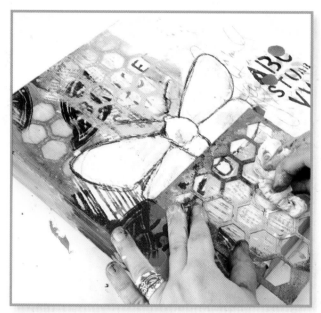

14 Paint blue paint above and below the traced image. Lay a stencil on the blue paint and rub through it with a baby wipe or damp cloth.

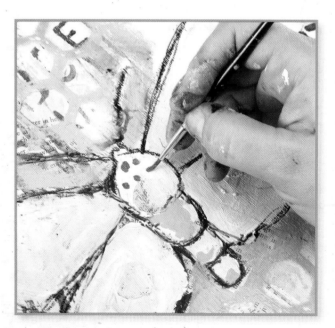

15 Add some color and details to the image with paint and Neocolor II crayons.

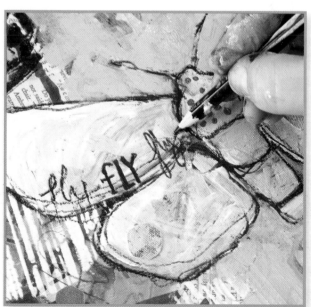

16 Add words to your image using a Stabilo All pencil.

Visit CREATEMIXEDMEDIA.COM/ART-JOURNAL-COURAGE for bonus downloads and more!

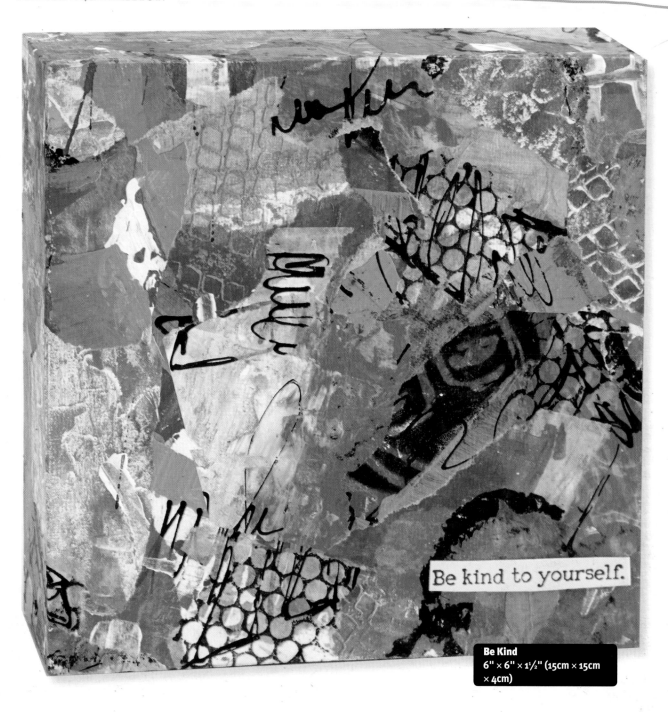

Be kind to yourself.

Be Kind
6" × 6" × 1½" (15cm × 15cm × 4cm)

Visit CREATEMIXEDMEDIA.COM to sign up for the free newsletter!

117

Creating a Canvas Journal

I love unstretched canvas. I buy it in big rolls so I can cut it to any size I want. I use it to make large scroll paintings and small journal covers, as I have for this technique. Canvas offers so many possibilities. You can paint on large pieces and then sew them into bags or tablet covers. You can make art quilts, pillow covers, even curtains!

MATERIALS

6 sheets of 9" × 12" (23cm × 30cm) watercolor paper

acrylic paint

acrylic spray sealer

Archival black ink pad

fun foam

gesso

ink spray in pink

large envelopes

large tags

matte gel medium

Neocolor II crayons

neon paint pen

old book paper

paintbrush

piece of canvas 12" × 9½" (30cm × 24cm)

ruler

sewing machine (or a hole punch, needle and waxed linen thread)

Stabilo All pencils in black and white

stencils

1 Gesso the canvas and let it dry.
 Paint the canvas with three colors. I used teal, Hansa Yellow and Green Gold.

2 Make a foam print (see chapter six) and use Archival ink to stamp it onto some book paper.
 Dye some book paper with pink ink spray.

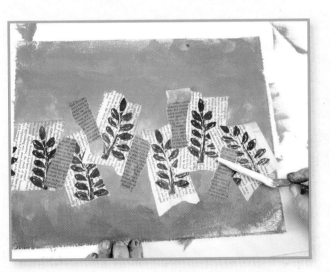

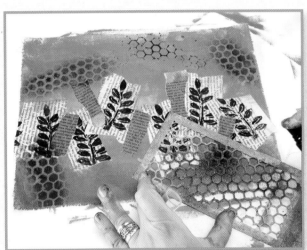

3 Tear up the book papers and glue them across the canvas with gel medium.

4 Use ink spray to add stenciling to some areas of the canvas. The spray won't work well on the gel medium but will be fine on the painted canvas.

Don't Waste Ink!

Remember to flip over the stencil and blot it in some of the areas of the canvas.

Visit CreateMixedMedia.com to sign up for the free newsletter!

119

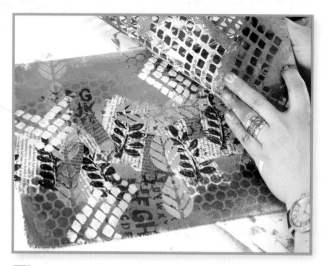

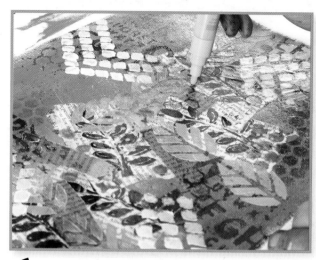

5 Use acrylic paint and an assortment of stencils to add stenciling to areas of the canvas. I did some stenciling with white paint, teal paint and purple paint.

6 Use Neocolor II crayons to add dots or doodles to the canvas.

Add neon dots to areas of the canvas with a neon paint pen.

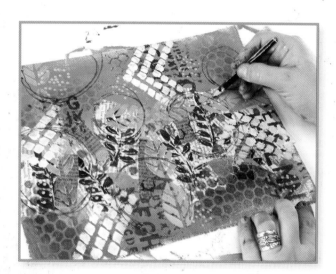

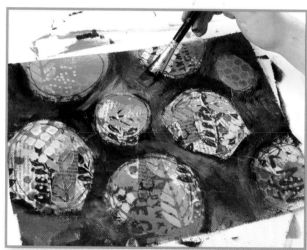

7 Use the black Stabilo All pencil to draw circles on the canvas.

8 Paint around the circles with dark blue paint.

Variety of Size

Vary the circle size and make sure some of the circles extend off the edge of the page. If you don't, the circles will look like they are floating in the middle of the canvas.

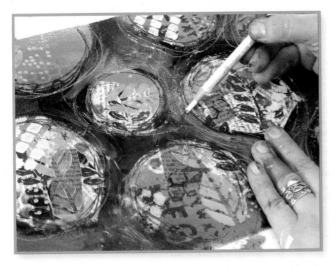

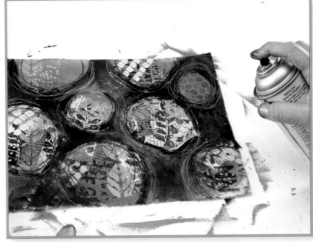

9 While the dark blue is still wet, add some white and blend it in.

Reinforce the circle lines by redrawing them with the black Stabilo All pencil.

Use the white Stabilo All pencil to add scribbly lines around the circles.

10 Repeat the process to the back side of the canvas so both sides are decorated.

Seal the canvas with spray sealant. Remember to spray both sides and to let it dry thoroughly.

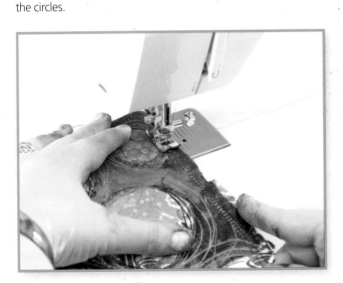

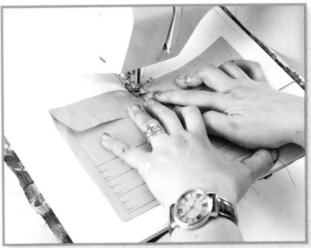

11 Sew around the edge of the canvas a few times.

12 Fold the sheets of watercolor paper in half. Nest them into three signatures of two sheets each. Add folded tags to the signatures, and any other papers you like. I used a large envelope.

Find the center of your canvas piece.

Measure ¼" (6mm) to the right of the centerline, and mark a line down the canvas.

Measure ¼" (6mm) to the left of the centerline, and mark a line down the canvas.

Sew the signatures in along the lines you marked. Use a sewing machine, or if you don't have a machine, you can punch holes and sew the signatures with a needle and waxed linen thread.

Enjoy your new journal and fill it with amazing art!

Find the Center

To find the center of a canvas piece, I like to fold it in half and then draw along the fold line with a white Stabilo All pencil so I can see the line.

Visit CREATEMIXEDMEDIA.COM to sign up for the free newsletter!

121

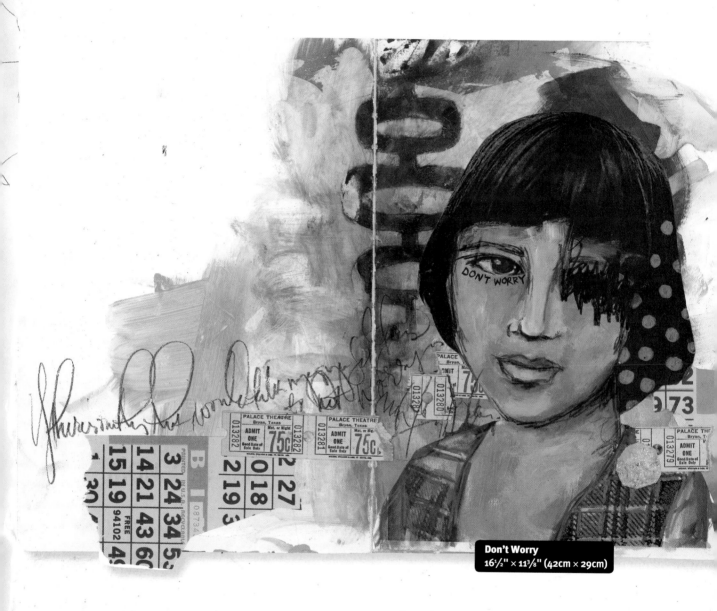

Don't Worry
16½" × 11⅜" (42cm × 29cm)

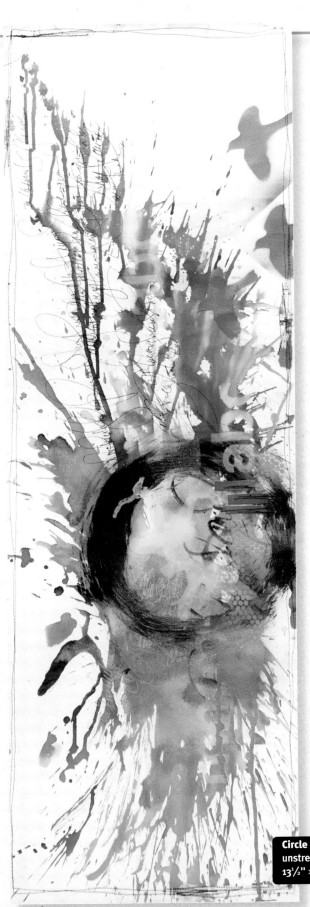

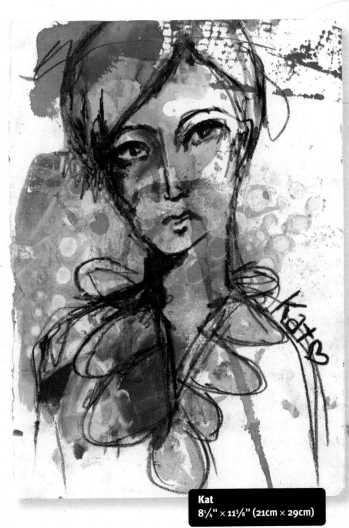

Kat
8¼" × 11⅜" (21cm × 29cm)

Circle Expression
unstretched canvas
13½" × 40" (34cm × 102cm)

Visit CREATEMIXEDMEDIA.COM to sign up for the free newsletter!

123

Acknowledgments

Thanks to Amy Jones, Geoff Raker, Christine Polomsky and the whole North Light team for making this book awesome.

Thanks to Ranger Ink for taking a chance on me and letting me dream big.

Thanks to Roger Tory Peterson for inspiring the bird images seen in this book.

Thanks to my friends who love me, support me, feed me and talk me off the ledge when necessary: Krista, Dyan, Su, Amber.

Thanks to my parents and family for being my biggest fans.

Thanks to my fellas for making life full, exciting and loud.

Thanks to Reed for love, partnership, kindness, acceptance and willingness to eat frozen meals and fast food when I am overwhelmed.

Dedication

To Reed and "the fellas"—Curtis, Cole and Carter. They are joy.

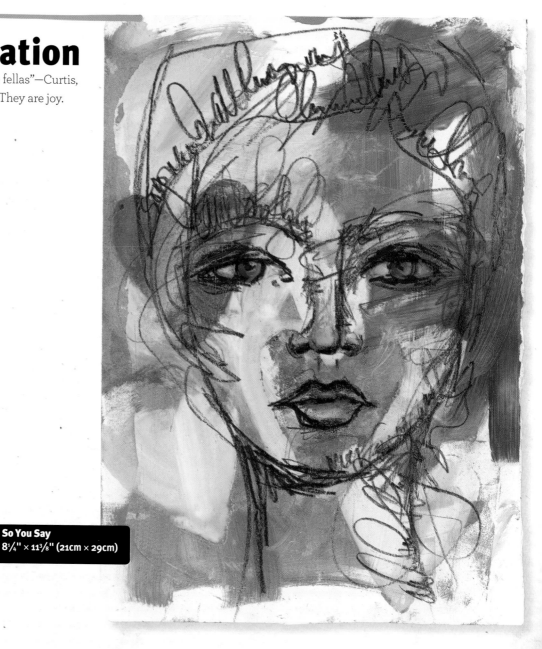

So You Say
8¼" × 11⅜" (21cm × 29cm)

Visit CreateMixedMedia.com/art-journal-courage for bonus downloads and more!

About the Author

Dina Wakley is a mixed-media artist and teacher. She loves everything about art: creating it, thinking about it, looking at it and teaching it. She lives in sunny Arizona with her husband and three boys. Dina's work has been published in many magazines and books.

Dina is passionate about teaching art. She teaches both in-person and online workshops. She is a docent at the Phoenix Art Museum, where she gives tours to school groups and gets kids excited about art.

In partnership with Ranger Ink, Dina designed a line of mixed-media art supplies that includes acrylic paints, mediums, brushes, rubber stamps and stencils. Look for the Dina Wakley Media Line by Ranger at a store near you or online at rangerink.com.

Dina loves hanging out with good friends, reading good books, cooking good food and traveling to good places.

You can visit Dina at dinawakley.com.

Visit CreateMixedMedia.com to sign up for the free newsletter!

125

Index

Visit CREATEMIXEDMEDIA.COM/ART-JOURNAL-COURAGE for bonus downloads and more!

Other fine North Light Books are available from your favorite bookstore, art supply store or online supplier. Visit our website at fwmedia.com.

a content + ecommerce company

18 17 16 5 4

DISTRIBUTED IN CANADA BY FRASER DIRECT
100 Armstrong Avenue
Georgetown, ON, Canada L7G 5S4
Tel: (905) 877-4411

DISTRIBUTED IN THE U.K. AND EUROPE
BY F&W MEDIA INTERNATIONAL LTD
Brunel House, Forde Close, Newton Abbot, TQ12 4PU, UK
Tel: (+44) 1626 323200, Fax: (+44) 1626 323319
Email: enquiries@fwmedia.com

DISTRIBUTED IN AUSTRALIA BY CAPRICORN LINK
P.O. Box 704, S. Windsor NSW, 2756 Australia
Tel: (02) 4560-1600; Fax: (02) 4577 5288
Email: books@capricornlink.com.au

ISBN 13: 978-1-4403-3370-5

Edited by Amy Jones
Design by Joan Moyers and Geoff Raker
Production coordinated by Jennifer Bass
Photography by Christine Polomsky

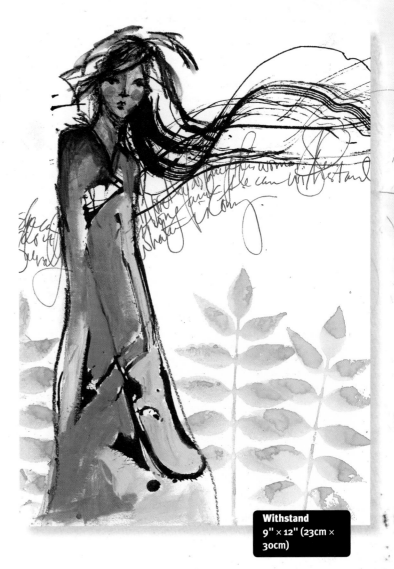

Withstand
9" × 12" (23cm × 30cm)

Metric Conversion Chart

To convert	to	multiply by
Inches	Centimeters	2.54
Centimeters	Inches	0.4
Feet	Centimeters	30.5
Centimeters	Feet	0.03
Yards	Meters	0.9
Meters	Yards	1.1

Visit CreateMixedMedia.com to sign up for the free newsletter!

127

Ideas. Instruction. Inspiration.

Receive FREE downloadable bonus materials when you sign up for our free newsletter at CreateMixedMedia.com.

Find the latest issues of *Cloth Paper Scissors* on newsstands, or visit Shop.ClothPaperScissors.com.

These and other fine North Light products are available at your favorite art & craft retailer, bookstore or online supplier. Visit our websites at CreateMixedMedia.com and ArtistsNetwork.tv.

Follow CreateMixedMedia for the latest news, free wallpapers, free demos and chances to win FREE BOOKS!

Visit ArtistsNetwork.com and get Jen's North Light Picks!

Get free step-by-step demonstrations along with reviews of the latest books, videos and downloads from Jennifer Lepore, Senior Editor and Online Education Manager at North Light Books.

Get involved

Learn from the experts. Join the conversation on